THE TOTAL BEAUTY OF

SUSTAINABLE PRODUCTS

Sust-aina-bility

can only be achieved

through better design.

THE TOTAL
BEAUTY OF

SUSTAINABLE PRODUCTS

Edwin Datschefski

RotoVision

A RotoVision Book
Published and Distributed
by RotoVision SA
Rue Du Bugnon 7
1299 Crans-Près-Céligny
Switzerland

RotoVision SA
Sales and Production Office
Sheridan House
112–116a Western Road
Hove, East Sussex, BN3 1DD, UK
Telephone: +44 (0)1273 72 72 68
Facsimile: +44 (0)1273 72 72 69
E-mail: sales@rotovision.com
Website: www.rotovision.com

10 9 8 7 6 5 4 3 2 1

ISBN 2-88046-545-1

Book designed by Lippa Pearce Design

Production and separations by
ProVision Pte. Ltd. in Singapore
Telephone: +65 334 7720
Facsimile: +65 334 7721

CONTENTS

Only one in **10,000** products is designed with the **environment** in mind.

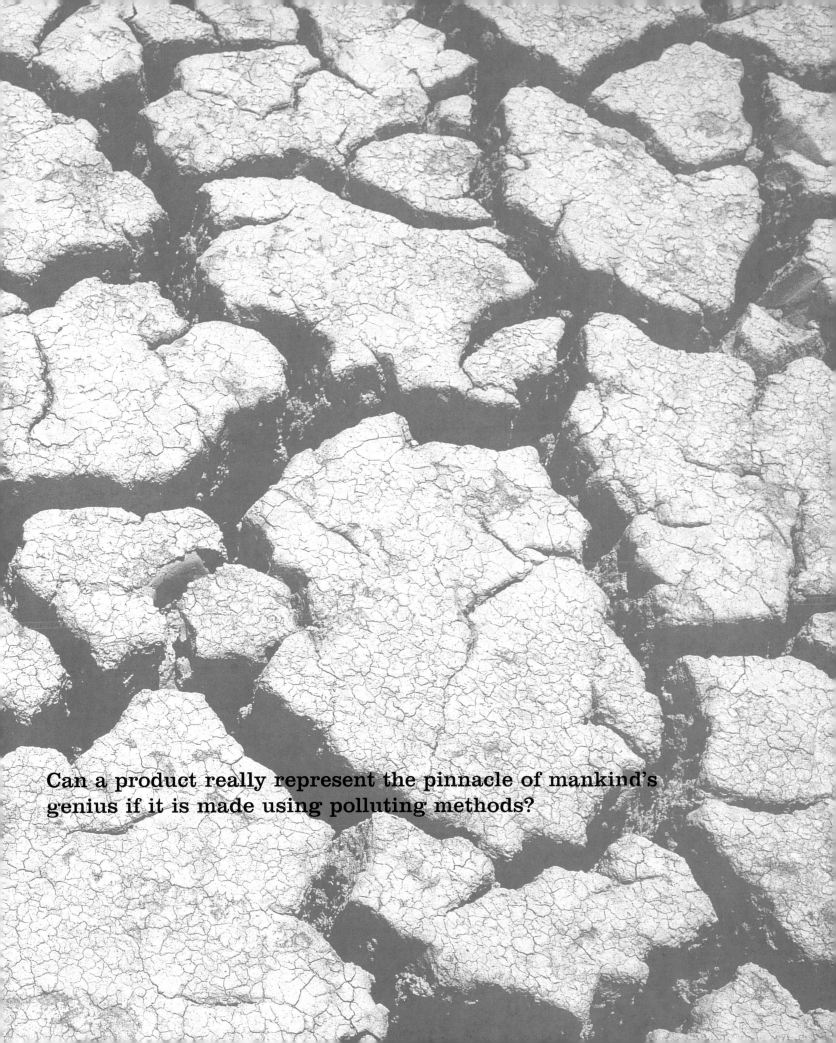

Can a product really represent the pinnacle of mankind's genius if it is made using polluting methods?

are not always as green as they appear, as they have hidden impacts like intensive forestry, toxic leather tanning and open-cast mining. There will also be lots of chrome and brightly coloured plastics, materials widely known to be bad for the environment.

In fact, the world is so fundamentally wrong when it comes to product design that it's hard to comprehend. For every sustainably designed product like the e.light, featured in this book, there are 10,000 products that have no environmental improvement whatsoever. Of course, most manufacturers comply with the few laws that cover environment, taking the lead out of paint or making their packaging more recyclable. But this is only the tip of the iceberg when it comes to what needs to be done.

This book aims to address that. Firstly it establishes a quick way of assessing how good a product is for people and the environment. And secondly it sets out the top five most common and effective ways of making a product more sustainable.

All over the world designers,

manufacturers and consumers are starting to look beyond the way products look and perform, to consider what goes on when products are made and what happens when they are eventually disposed of. They question, for example, that while an award-winning chair may look beautiful, whether it can really represent the pinnacle of mankind's genius if it is made using polluting methods or by exploiting workers.

Governments, communities and industry are all working to prevent pollution and overconsumption from ruining the planet and the natural resources we all rely on like oceans and forests. To support this, there is an urgent need to make all industrial products and processes 'sustainable' – good for people, profits and the planet.

As you will see in this book, a handful of enlightened manufacturers are starting to take sustainability seriously. Small numbers of new products are becoming available that have a 'total beauty' about them; their total life history, from the cradle of raw materials production to their end of life, has been designed to minimise environmental and social impact.

But if you go into most shops that stock 'designer' products you will not find any good examples of environmental performance. There may be a few minimalist items made of nice-looking wood and steel, but these

This is not just about the obvious things like recycled paper or electric cars. While there have been considerable improvements in the environmental performance of the usual suspects like recycled paper and concentrated soap powder, we must expand our horizons radically and start to look at everything, from hi-fis and golfclubs to doorhandles and lipstick.

Nobody challenges these products. No customers are demanding better versions in terms of environmental performance. Most people simply haven't thought about it, especially when the price and user performance are acceptable. This is where designers and product managers can make a difference. Collectively they must redefine how

products work and how they are made. There is an urgent need to redesign all products now. Sustainability can only be achieved through better design.

Environmental and social issues are complex and can seem hard to get to grips with. The approaches in this book build on the lessons learnt through many years' experience and hundreds of product innovations in order to make the challenge of sustainable design more approachable.

Sustainability is inevitable – it's now about who will be first to gain a beachhead. Already firms are claiming major strategic stakes in what will be a trillion-dollar business in the next five years. BP Amoco, Shell, DaimlerChrysler, Cargill Dow Polymers and Xerox have all got billion-dollar projects involving radical new product technologies such as solar panels, fuel cells, bioplastics and remanufacturing.

Design is the key intervention point for making radical improvements in the environmental performance of products. A 1999 survey by Arthur D. Little revealed that 55 per cent of senior executives in industry singled out design as the most important mechanism for their companies to tackle sustainability.

Another benefit of environmental thinking is that it is an abundant source for innovation. Product developers are running out of ideas – almost all new product areas are refinements of existing ones – the smaller laptop computer, the sleeker car, the wider screen TV, and so on. When the enormous might of the new digital economy can only offer fridges that alert you to being out of milk, you know that manufacturers are looking for direction. Sustainability can give that new direction.

Most designers focus on improving form and function, but fabrication – how products are made – is also vital. As we will see, fabrication is where many of the environmental and social impacts lie, with damage being caused by the extraction of raw materials and by pollution rising from manufacturing processes. This story of the whole life of a product is fascinating and in today's entertainment economy that is vital. Consumers are more sceptical than ever before, wary of claims and suspicious of companies' intentions. To restrict your work to form alone is missing out on shaping a huge part of the story.

Many of the examples presented here may seem unusual or radical. But what seems radical today will be mainstream tomorrow. Becoming 100 per cent sustainable is not only possible, it can be achieved within a few decades. By reading this book you will be taking the first steps towards becoming a sustainability-literate designer.

Good luck!

The chair is the classic design icon, so here I've chosen five chairs to illustrate the basic principles of sustainable product design.

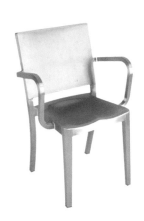

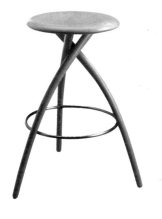

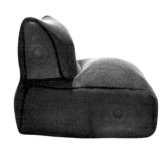

Cyclic

Solar

Efficient

Products should either be part of natural cycles, made of grown materials which can be composted, or else become part of a man-made cycle, like closed-loop recycling. This Emeco Hudson chair by Philippe Starck is made from 85 per cent recycled aluminium and is itself recylable

All the energy used to make or run the product should be from renewable energy in all its varied forms, most of which are ultimately driven by the sun. This C3 stacking chair by Trannon is made using young forest thinnings, a forestry by-product. To eliminate kiln-drying energy, they are designed to be steam-bent from green, using heat from wood waste.

Increasing the efficiency of materials and energy use means less environmental damage. Products can be designed to use one tenth of what they did before. The SoftAir inflatable chair does just that.

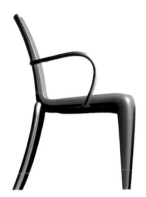

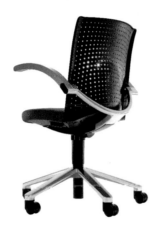

You will notice that some of these chairs have used more than one of the principles. For example, the SoftAir and the Louis 20 are 99 per cent recyclable. The Trannon is made without synthetic varnish. The Picto is durable and easy to repair, 95 per cent recyclable, has no glued or welded joints, and the factory is partially solar-powered.

A totally beautiful sustainable product is 100 per cent cyclic, solar and safe. It is also super-efficient in its use of materials and energy and is made by a company that actively seeks fairness for its employees and suppliers.

Safe

Products and, importantly, their by-products, should not contain hazardous materials. The Louis 20 chair by Philippe Starck for Vitra avoids the use of glues with its clever joint construction which uses only six screws.

Social

A product cannot be great if its manufacture exploits workers. This Picto chair is made by Wilkhahn, a company which practices fairness and co-operation. Its employees have a 50 per cent share in operating profits, and there are only two management levels, giving everyone the chance to participate in decisions.

"**Man** is the only

animal

that blushes ●

●

or needs to"

Mark Twain

THE HIDDEN UGLINESS OF AN ORDINARY DAY

The Hidden Ugliness of an Ordinary Day

Products are the source of all environmental problems. It may seem surprising, but most environmental problems are caused by unintentional side-effects of the manufacture, use and disposal of products.

An individual product may look harmless enough, but the environmental damage it causes happens elsewhere, out of sight and mind, 'hidden' from the consumer and often from the designer as well. Major issues such as pollution, deforestation, species loss, and global warming are all by-products of the activities that provide consumers with food, transport, shelter, clothing and the endless array of consumer goods on the market today. I call this the 'Hidden Ugliness' of products.

Many environmental impacts are literally invisible, making them hard for people to be aware of. Vapours and gases float around unseen, causing damage to people's lungs or to the ozone layer. Pesticides and other pollutants can be found in perfectly clean-looking water. Radiation from nuclear or electrical sources also can't be seen or even sensed without special equipment. You've got to study products closely to see what's really going on.

For example, over 30 tonnes of waste are produced for every one tonne of product that reaches the consumer. And then 98 per cent of those products are thrown away within six months. When you include these hidden impacts of manufacturing, we each consume our own body weight in materials every two days.

There is hidden ugliness beneath the surface of almost all products:

> " The **world** we have is the **product** of our way of thinking. "
>
> Albert Einstein

Computer

About a quarter of a computer is plastic, mostly the casing. It's a candy-coloured translucent plastic called polycarbonate, the same stuff that CDs are made from. It is made from phosgene, which was used as poison gas in the First World War, and Bisphenol A, an endocrine disruptor.

Workers at silicon chip factories in Scotland and America have unusually high levels of cancer, with even people in their twenties falling ill.

And it's not just in the factories themselves. Each plant has emissions to air and water. Two thirds of America's most polluted sites are in Silicon Valley.

The gold in circuit boards of a PC may have come from Romania, where a gold mining accident caused one of the worst river pollution accidents in Europe. Environmental damage from gold extraction is routine; for every ounce of gold extracted in Brazil, there are nine tonnes of waste, including silt and mercury run-off which kills fish and other aquatic life downstream.

Computer junking is also happening at a faster rate. The lifespan of computers is only about three to five years. Despite a significant increase in computer recycling, every year about 30 million computers are dumped, incinerated, shipped as waste exports or put into temporary storage or people's attics.

Chair

The steel for the frame was made in Europe from pig iron, from ore that had been dug out of a huge open-cast mine in Brazil that had originally been forested land. A steel mill will burn about 20kg of coal to make the steel for one chair.

The steel for many chairs is chrome-plated to make it look shiny. Wastes from the chromium-plating process are dumped in rivers, especially in developing countries, damaging fish and making the water undrinkable.

The plastics in the chair, such as the arms and the polyurethane foam padding, are all products of the oil industry. One of the concerns about oil is that it is inevitably spilt in oceans and rivers.

The leather seat was made by taking the skin of cow and treating it with a variety of substances, including mineral salts, formaldehyde, coal tar derivatives, and various oils, dyes, and finishes, some of them cyanide-based. Most leather is chrome-tanned, meaning that chairs can give the environment a double dose of chrome pollution.

" The veneration of

progress

for its own

sake has

resulted

in a world

where things

take precedence

over people. "

Philippe Starck

Clothing

The manufacture of a T-shirt requires the use of 150g (1/3lb) of chemical fertilisers and pesticides. Cotton accounts for 25 per cent of the world's insecticide use. And farm workers exposed to excess toxins are at risk from poisoning and health problems.

A study in Ghana revealed that some farmers are so used to using pesticides without protective clothing that they actually feel proud when they feel a bit sick at the end of the day, because it shows the chemicals are working properly.

Some wool-producing countries require all sheep to be dipped in strong chemicals. This sheep dip is linked with farmers feeling suicidal and suffering from memory loss.

Many clothes are sewn together by part-time workers who make less than the legal minimum wage, and who are forced to work long hours and unpaid overtime.

Some manufacturers still use a third of a litre (12oz or a typical drink's can size) of adhesive to make just one pair of athletic shoes.

Lamp

A typical desk lamp will use 1,200kWh of electricity during its ten-year life. This would require about half a tonne of coal to be burnt at the power station, or in most countries a more complex mix of fuels such as oil, natural gas and uranium oxide.

The copper in the wires of a lamp could have come from the Panguna copper mine on Bougainville in the North Solomons, where about half a billion tonnes of waste ore were discharged into the local river, killing all aquatic life. Their livelihood and food source ruined, the local people resorted to armed conflict against the mining company and successfully booted them out, creating their own independent republic.

The bulb contains mercury, a toxic heavy metal. When the bulb blows it may get thrown out with the normal rubbish and dumped in a landfill, increasing the risk of mercury leaking into drinking water.

Every year, more mercury ends up as emissions to air, water and soil than there is mercury used in products such as batteries, fluorescent tubes, electrical equipment, paint and tooth fillings.

The base and neck of the lamp is made of aluminium. It weighs about 2kg, which means that 100kg of waste was produced in order to make it.

"**Man** is the only species capable of generating **waste** – things that no other life on earth wants to have."

Gunter Pauli, Industrial Ecologist

Magazine

It takes 5kWh of energy to turn wood into a thick magazine, enough energy to run a lamp for 100 hours. It takes as much energy to make a tonne of steel as it does to make a tonne of paper.

Glossy paper is in fact only about 70 per cent paper. The rest is made up of fillers and clays.

Inks based on heavy metals such as arsenic, cadmium and lead have now been largely phased out. However, there are still concerns about the toxicity of the latest generation of dyes. Yellow 12 is widely used in full-colour printing, and its ingredients include 3,3'-dichlorobenzidene, a known carcinogen which is also a suspected liver and kidney toxicant.

The printing process produces a variety of wastes, including isopropanol alcohol, contaminated water, some silver from platemaking, and various cloths, inks, solvents and cleaning chemicals.

Hardly any of the products mentioned in design magazines are sustainable. In fact, some of the products receiving praise cause known environmental problems.

Summary

What you have just read about the computer, chair, clothing, lamp and magazine is just a snapshot of what's going on. There are many things about these products, both good and bad, that I have not had the space to mention.

Overall, the design and manufacture of products is certainly not all bad. There has been a lot of improvement. Billions of pounds are being spent on cleaning up industry, and environmental laws are getting stricter every day. But are these measures enough? The answer is clearly no, as the environment is still in a mess.

'Legalised pollution' is the problem – firms are allowed to put smoke into the air and poisons into the water, as long as they do not breach a certain agreed level. You are legally allowed to put pollutants into the air when you drive your car. But just because these things are legal does not mean that they are right.

Most companies try and comply with the local laws where they manufacture goods. And some of those laws are about the environment. But passively complying with environmental laws is not the same as actively designing to improve the environmental performance of a product.

Legislation allows pollution. Even if all companies comply with the law, there will still be substantial levels of toxic releases that cause damage to ecosystems and people. The pollution is allowed on the basis that releases will 'dilute and disperse' in the air or water and so be rendered harmless. However, some chemicals do not simply dilute over time – they accumulate in ecosystems and can come back to haunt us.

It's no longer enough that a product is pretty on the outside, cheap and available. We owe it to the coming generations who will have to clean up our products in the future to manufacture in harmony with nature.

"A good design goes beyond

appearances"

Axel Thallemer, Head of Corporate Design, Festo AG & Co.

TOWARDS TOTAL BEAUTY

Towards Total Beauty

Ecological and social issues are becoming more important than ever before, and a vital new role is opening up for design. We've seen how beautiful-looking products have an underlying ugliness. We have to reveal all these hidden environmental and social impacts and create products that have a 'total beauty'. These products, also known as 'sustainable products', are those that are the best for people, profits and the planet.

When you've been looking at sustainable products for a while, you notice that the same solutions come up time and again. Based on a review of 500 products, I found that 99 per cent of all environmental innovations use one or more of these five principles:

Cyclic
The product is made from compostable organic materials or from minerals that are continuously recycled in a closed loop

Solar
The product in manufacture and use consumes only renewable energy that is cyclic and safe

Safe
All releases to air, water, land or space are food for other systems

Efficient
The product in manufacture and use requires 90% less energy, materials and water than products providing equivalent utility did in 1990

Social
Product manufacture and use supports basic human rights and natural justice

So despite all the complex lifecycle analyses people make, there are relatively few improvement options open to product developers. This also means that it is probably easier than people think to come up with environmental innovations.

These five design principles are defined more closely in the next section of this book.

Waste Waste Waste Waste Waste Waste
Waste Waste Waste Waste Waste Waste
Waste Waste Waste Waste Waste Waste
Waste Waste Waste Waste Waste Waste
Waste Waste Waste Waste Waste Waste
Waste Waste Waste Waste Waste Waste
Waste Waste Waste Waste Waste Waste
Waste Waste Waste **Waste** Waste Waste
Waste Waste Waste Waste Waste Waste
Waste Waste Waste Waste Waste Waste
Waste Waste Waste Waste Waste Waste
Waste Waste Waste Waste Waste Waste
Waste Waste Waste Waste Waste Waste
Waste Waste Waste Waste Waste Waste
Waste Waste Waste Waste Waste Waste
Waste Waste Waste Waste Waste Waste
Waste Waste Waste Waste Waste Waste
Waste Waste Waste Waste Waste Waste

$\left(\text{is lost profit}\right)$

Cyclic:
Products that are made from compostable organic materials or from minerals which are continuously recycled in a closed loop.

The basic protocol for cyclic product manufacture is very simple: use materials in cycles, and instead of emitting waste and poisons, only emit materials that can be 'food' for something else.

We've often heard that we're running out of resources. But there are still the same number of atoms around on the earth's surface – we have simply converted atoms into molecules that are of no use to us. With continuous cycling of both organic and inorganic materials, we will never run out of the resources we need.

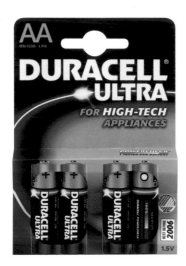

1

Recycle

The goal of being cyclic is to have continuous cycles of materials, with mineral materials being sourced from the collection of end-of-life products and by-products. This will be 'closed loop' or true cycling, and not 'downcycling', which is when materials become contaminated in use and can only be recycled as lower grade materials. For example, plastic packaging is often coloured or printed on, making closed-loop recycling difficult, as when the coloured plastics are mixed together, they turn into a sludgy brown colour. This is why recycled plastics often end up being turned into black dustbin liners...

What is recyclable? In theory everything is recyclable, but in practice there are technical and economic challenges. A pure material becomes less recyclable as colours, barrier coatings, adhesives and labels are added to it.

Designing for recyclability involves:
• making sure that the product can be disassembled easily;
• labelling of parts to indicate materials types used – usually by embossing to avoid contamination;
• ensuring that surface finishes and graphics or decoration do not irreversibly contaminate the materials.

Plastic parts should be labelled with the recycling triangle with a number inside to help consumers and recyclers identify the type of plastic for segregation:

1 is PET (Polyethylene Terephthalate)
2 is HDPE (High-density Polyethylene)
3 is PVC (Polyvinyl Chloride)
4 is LDPE (Low-density Polyethylene)
5 is PP (Polypropylene)
6 is PS (Polystyrene)
7 is all other plastics

2

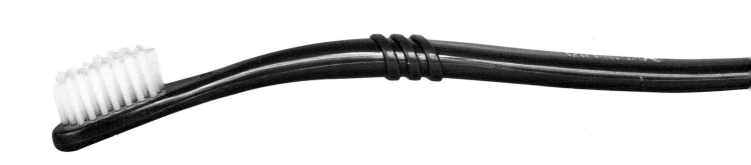

3

Re-use

Recycled products rely on the raw materials being crushed or melted down before they are reformed into a new product. But it is often easier to keep the form of the original product, and simply clean it or re-use it again. Examples of this are familiar to us all – pallets, returnable beer and milk bottles, and reconditioned car engines.

Remanufacture

When manufacturers collect their own products once the consumer has finished with them, it is known as product takeback. The manufacturer then has a choice of melting down the materials and reforming them, or keeping the components and refurbishing them to go into new products. The refurbishing route is the more sustainable, and if the process (also known as remanufacture) is technically sound, then the remanufactured products can be as good as new. Examples include photocopiers (Xerox), computers (Dell, Compaq and ICL), car engines and single-use cameras.

1. Duracell 'blister-free' blister pack for AA batteries
Recycle: The 'monomaterial' approach was achieved by Duracell, who made blister-free packaging for their batteries. Before this innovation, their retail battery packaging consisted of a cardboard back with a transparent PVC bubble that prevented tampering and allowed buyers a view of the product. Duracell use a clever folding system of cardboard only, with a photo on the packaging that gives a trompe l'oeil effect to show the whole product.

2. Dahle recycled scissors
Recycle: Dahle make the handles of their recycled scissors from post-consumer waste plastic, and the steel is also from a recycled source.

3. Recycline toothbrush
Recycle: The Preserve by Recycline is a recycled toothbrush that is available on subscription. Once one wears out, you post it back to them for recycling, and they send you a recycled one back. The handle is 20–30 per cent post-consumer polypropylene, but the bristles are virgin nylon. At present the collected brushes are made into garden furniture, but they are also planning a black closed-loop recycled product.

4. Tear-strip envelope
Re-use: This secure envelope is opened with a tearstrip. It can then be resealed and sent back, with bill payment for example – a great example of re-use.

PULL STRIP

Reseal using gum on side flap

4

Grown

Plant materials are cyclic in origin, as they are made from CO_2, water, and small amounts of minerals recycled from the soil. Likewise, animal-derived materials are themselves taken from plants, and both can be broken back down and returned to the ecological cycle by means of composting.

Grown materials such as wood and cotton are already very familiar, but a cyclic-grown innovation is usually about using plants for new industrial purposes such as oils, fibres and plastics.

Just because something is plant-based does not necessarily mean that it is a good environmental performer. For example, industrial cleaning fluid can be made with d-limonene, derived from the peels of oranges. But it may be toxic to aquatic organisms, and can definitely cause skin allergies; gloves are essential. The probable lethal dose in a human adult would be one fluid ounce, and it's combustible, so it's definitely not like orange juice! Despite this, it's still a lot less toxic than the synthetic solvents used to do the same jobs.

It pays to be cautious, as even organic production is not as good as it could be. Despite all these caveats, the use of cyclic-grown materials is generally a positive step environmentally. It's a question of knowing your materials, even down to the detail of which country and which farm they come from.

5

5. Wooden cutlery
Many things that are made in plastic or metal that have fairly simple shape and low stress requirements can be made with wood instead.

6. Teak bicycle
Even bicycles can be made from grown materials like bamboo, ratten or hickory. The one shown here is made of teak which was plantation-grown in Java, one of the few sustainable sources of this wood.

6

The possibilities are ever increasing. Products and processes are being transformed as plastics, fuels, and drugs are being mass-produced from plants. Traditional mineral-based industries are becoming more organic by re-using materials and reducing toxicity. Here are some examples:

Biofibres as strong as E-glass or even kevlar are made from hemp and flax and have applications as panels, building materials, TV and computer cabinets, furniture, packaging and various reinforced materials. Hemp fabrics are used by Calvin Klein and Ralph Lauren. Adidas have made training shoes from it, and Mercedes uses it as a filling for car seats.

Bioplastics like Biopol, NatureWorks and Mater-Bi are made from plant starch, and have good structural performance, even though they are biodegradable. Polylactic acid (PLA) is being used for bags, cutlery, plates, pens, clothing, credit cards, food packaging, agricultural films, tea bags, coffee filters, diapers and napkins.

Biodigestion is the obvious solution for disposing of organic materials. In areas of rural India they are becoming widespread, converting sewage and animal waste into biogas, a mix of CO_2 and methane, which is used for cooking. Many rural areas in the UK have reedbeds for sewage treatment, and the firm Living Machines has developed vats of waterplants to treat wastewater that includes heavy metals and other industrial effluents.

Biodeath. All good things come to an end, including you. Conventional burial in hardwood or metal coffins, placed deep in nonproductive land, is not good nutrient cycling. A cardboard coffin offers speedy decomposition.

In Tibet there are no trees to make coffins or for fuel for cremation, and the ground is rocky or frozen hard. Given that background, the approach known as 'Sky Burial' seems very appropriate – taking the body, whose soul has already been transferred to celestial space, and using it to benefit other living beings. This is achieved by a ceremonial feeding of the local vultures. **Now that's cyclic!**

"Each day more solar energy falls to the Earth than the total amount of energy the planet's

6 billion

We've hardly

inhabitants would consume in

25 years.

begun to tap the

potential of solar energy."

US Department of Energy

Solar:
Products in manufacture and use consume only renewable energy that is cyclic and safe.

The solar requirement means that all materials flow and energy use is powered by photosynthesis, muscle or renewable energy. This covers products with mounted photovoltaic solar cells, or those hooked up to a mains supply powered by wind, wave, biomass, or PV, through to products that are grown or operated by hand. This also applies to 'embodied energy' – the energy used to provide a service or to manufacture and distribute a product.

Products that consume energy when they are used often can have their environmental performance increased significantly by switching to different forms of power. For vehicles and household appliances, the impact of energy in use is far bigger than the environmental impacts caused by manufacture or disposal.

PV

Photovoltaics (PV), which harness the sun's energy, are particularly useful for local and mobile applications, although their manufacture is not yet entirely cyclic or safe. While some firms are pursuing techniques using toxic compounds such as cadmium telluride, there is also research into completely safe methods that mimic plant structure.

PV can also be used as cladding for buildings, a solution which is actually cheaper than polished granite or marble. Another option is to use PV roof tiles like the Uni-Solar shingles installed on the Solar Century showhouse in Richmond, London. A typical UK house can be fitted out for about £12,000, and the tiles look just like a normal roof, albeit with a slight purple sheen.

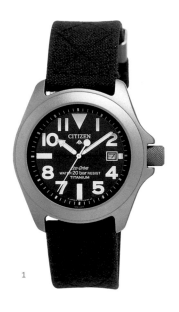

1

2

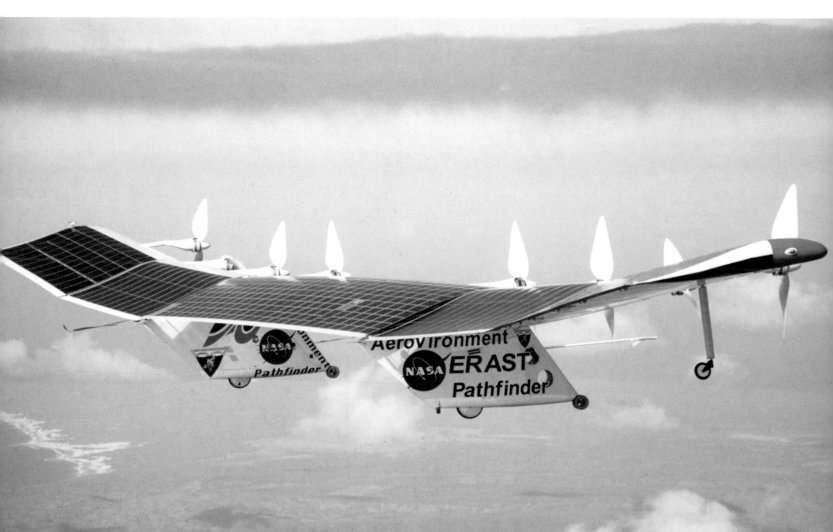

Fossil fuels

Fossil fuels are stored solar energy, but they are not cyclic or safe. If you could extract fossil fuels without spilling any, and have perfect combustion (which means no NOx, SOx, particulates etc.), and you can capture and keep the CO_2 to avoid global warming, then all you are doing is releasing solar energy that has been in extremely long-term chemical storage. But this is really not practical. It would be easier to use renewables.

While fossil fuels have a limited use in the future, they have enabled today's industrial society to come into existence – it's rather like the earth's mother's milk, which supports the industrial baby. When the milk dries up, it's time for the baby to be weaned off fossils and onto proper food – solar power in all its forms. A bit of toilet training wouldn't go amiss either...

3

1. Citizen Promaster tough solar watch
PV: The range of products with PV cells is amazing: calculators, radios, watches, mobile phones, boats, planes, electric fences, parking meters, bikes, cars, smoke alarms, hearing aids, cameras and watches like the Citizen Promaster tough solar watch.

2. NASA's Pathfinder-Plus solar-powered aircraft
PV: The Pathfinder-Plus is a lightweight, solar-powered, remotely piloted flying-wing aircraft with a 98-foot wingspan. It was flown to a world altitude record of approximately 80,000 feet. Solar arrays covering most of the upper wing surface provide up to 12,500W of power at high noon on a summer day to power the aircraft's six electric motors, avionics, communications, and other electronic systems.

3. CookSack portable solar oven
PV: Direct sunshine is also a huge source. Such 'passive solar' power is used to heat water, buildings and to dry fruit and vegetables. Used for cooking, a wide range of solar cookers are popular in developing countries. The same approach has been used to make a camping stove called the CookSack. It's an inflatable polyester film bag with a reflective panel that captures the heat energy of the sun and focuses its power on a cooking pot. It can reach 88 °C, fine for cooking.

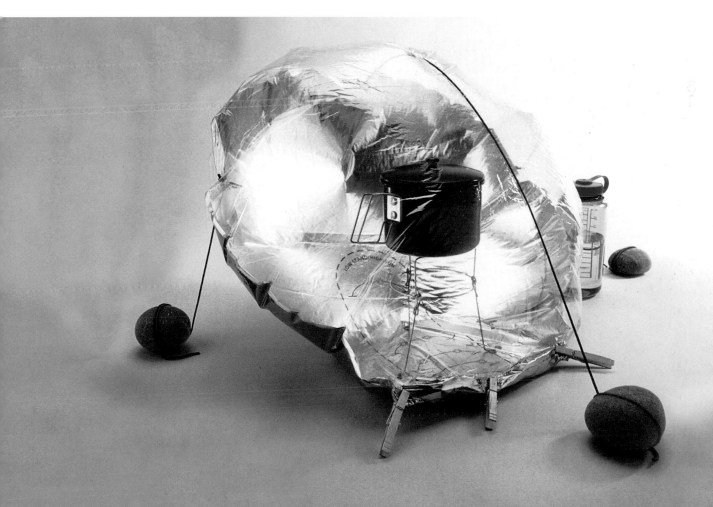

4. Taxi bike

Muscle power: The human-power taxi bike, which is basically a four-wheeled freight bicycle, is used widely in the UK for applications including park gardening. The Red Star courier service uses the bike in the London City area instead of cars. The taxi bike is an update on the rickshaw, with much better gears and a lighter weight.

5. Patagonia fleece

Alternative energy: Patagonia uses renewable energy to produce its product, thereby achieving an approximate 20 per cent reduction on its electricity consumption. So although it will pay a small premium for using 100 per cent renewable energy, its net costs are less.

6. Brompton folding bicycle

Muscle power: Folding bicycles by Brompton, Bernd, Moulton and Birdy allow cyclists to take their bikes on trains and keep them inside offices, removing two of the major barriers to urban cycling.

7. Seiko thermic watch

Muscle power: Seiko's thermic watch provides Quartz accuracy by converting body heat into electricity.

"s `Freiburger Stadt-Rädle"
CITY CYCLE CAB (R)

the
pickup

4

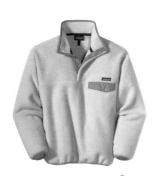

5

Biofuels

Biofuels have always been around. Brazil in particular has used petrol with 20 per cent ethanol from sugar cane for 30 years. Biodiesel made from rapeseed oil can be used in vehicles with very little modification. More than 500 filling stations in Germany are already supplying biodiesel. While they give off CO_2 when burnt, this CO_2 is part of the current carbon cycle, not adding to it as fossil fuels do. A recent innovation in Switzerland allows the making of ethanol from waste cellulose, a major breakthrough as previously only food crops such as sugar beet could be used for this purpose.

Wave power

Wave power has vast but rarely tapped potential; the energy contained in the waves off the Scottish coast has the potential to provide almost three times the electricity needs of the whole of the UK.

Muscle power

Muscle power is a form of solar energy, as the sun powers the plants which then power us when we eat them. Examples of using muscle power include the taxi bike, the Brompton folding bicycle and the Seiko thermic watch.

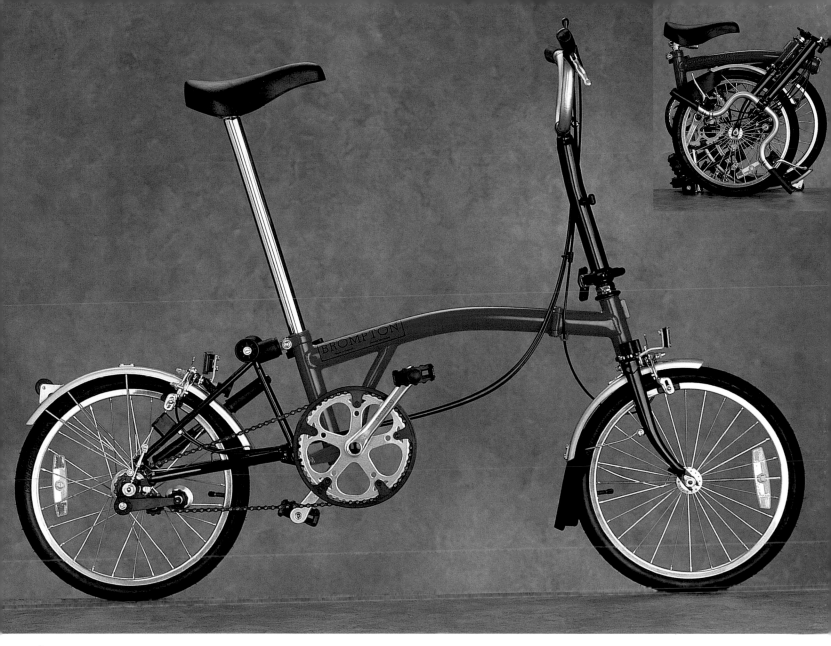

6

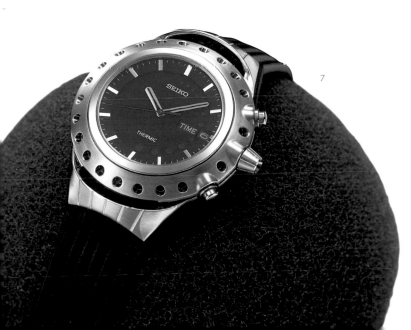

7

Alternative energy in manufacture and distribution

The energy used to manufacture something is known as embodied energy or 'embergy'. For products that are inert in use, the embergy can be a large percentage of the overall impact. Even with energy-consuming products, embergy can still be significant. For watches and radios, about half the energy use occurs during manufacture.

Patagonia is one of the very few firms so far to have started manufacturing with renewable energy. Although using renewable energy carries an incremental cost, the company has taken a number of steps to neutralise these costs. By investing in new lighting, insulation, and new, more efficient motors to drive the conveyor belts, Patagonia has achieved a 20 per cent reduction on its electricity consumption.

"A thing is

right

when it tends to preserve the

integrity, stability and beauty

of the biotic community.

It is

wrong

when it tends otherwise."

Aldo Leopold

Safe:
All releases to air, water, land or space are food for other systems.

The definition of 'Safe' needs some explanation. A safe process or product cannot chemically or physically disrupt people or other life. A 'release' is a deliberate or accidental discharge of materials to air, water or land. This obviously includes liquid effluent from pipes, smoke from chimneys, and spills onto the ground. However, as all products are ultimately disposable, it also includes products themselves. If there is no plan or system for product takeback and full re-use and cyclicity, then every product sold represents a toxic release. 'Air, water, land' is obvious, and 'space' is included in the definition and refers to outer space, because more and more junk is being left in orbit. 'Food for other systems' encapsulates the idea that in nature, although there are waste products such as autumn leaves, there is always another organism that can make use of them.

Do we need chemicals?

There is a mistaken assumption that to be effective, a 'nasty chemical' is necessary. In a now-famous example, Rohner Textil commissioned an analysis of 8,000 chemicals used in fabric manufacture, and found only 38 that were completely free of any concerns about causing birth defects, genetic mutations or cancer. Fortunately, they could get all the colours and meet all the performance criteria such as fire retardance and strength with fabric made using just these 38 compounds.

Amazingly, regulators found that the effluent leaving the factory was actually cleaner than the water going into it, because the fabric was filtering the water. The fabric mill also recycles all scrap and waste. It contracted with a consortium of strawberry farms to press the scrap fabric into felt used instead of plastic as a ground cover, insulator, and weed inhibitor. After repeated composting trials, the product was proven to be biodegradable into soil, leaving behind no toxic substances.

1

Dilution is not the solution

The standard 'dilute and disperse' approach assumes that chemicals are innocent unless proven guilty. This works fine for human justice, but is a lousy policy for chemicals. Time and again, compounds that were believed to be safe have turned out to be harmful.

That's why the cyclic|solar|safe approach doesn't ask "show me how it's bad", but instead asks "how does this release help the system it's entering?" If it's not helping, if it's not food for the receiving system, then it's clearly not safe. We want to know what happens to releases; where they go and what their chemical pathways are.

Habitats

Safe also means that habitats are not disrupted. The maintenance of ecosystem integrity requires that forests and seas are not over-harvested. For example, clearing of virgin forests or overfishing are not sustainable. Ecosystems can also be disrupted by physical means, such as the building of roads and fences through habitats which may prevent migration of wildlife.

For every product, there is always a safer material or compound that can be used, but the challenge is to match or exceed the performance of the original toxic solution.

Dissolving solvents

Traditional adhesives contain petroleum-based solvents that are air pollutants which contribute to photochemical smog and pose health hazards to humans.

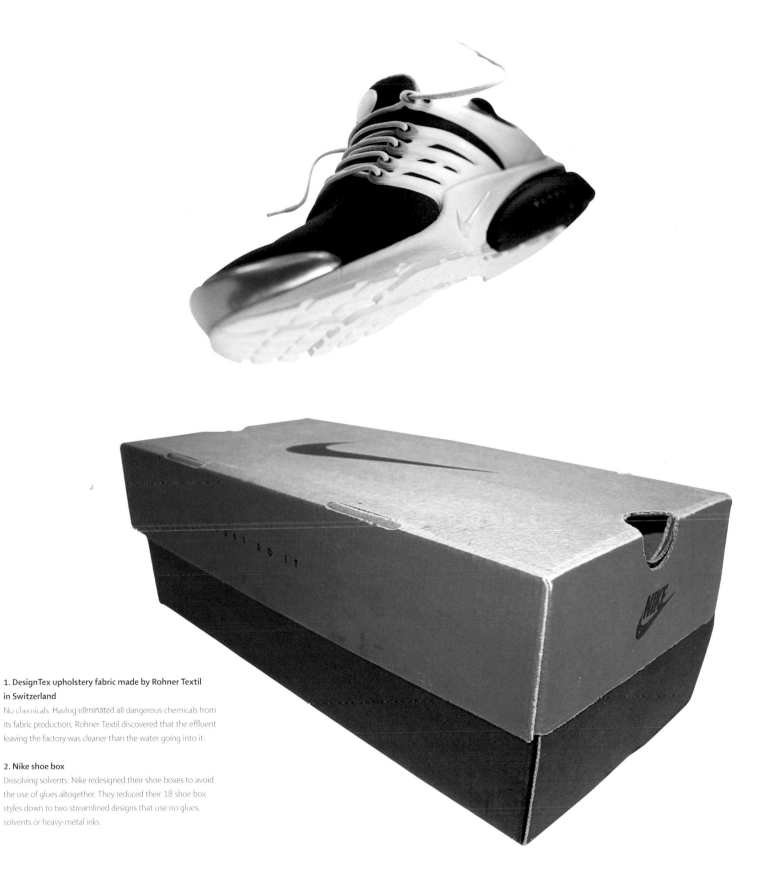

1. DesignTex upholstery fabric made by Rohner Textil in Switzerland

No chemicals. Having eliminated all dangerous chemicals from its fabric production, Rohner Textil discovered that the effluent leaving the factory was cleaner than the water going into it.

2. Nike shoe box

Dissolving solvents: Nike redesigned their shoe boxes to avoid the use of glues altogether. They reduced their 18 shoe box styles down to two streamlined designs that use no glues, solvents or heavy-metal inks.

Lead-free bullets

Another way to reduce toxicity is to eliminate the use of heavy metals such as mercury and lead. Most bullets are used for target practice, and here they create a different hazard. Dust and vaporised lead presented a severe health risk to those training on indoor ranges, and dozens of US Army shooting ranges were forced to close. In 1999, they replaced the lead with tungsten, and also eliminated ozone-depleting chemicals and volatile organic compounds from the bullet manufacturing process. Although tungsten is more expensive than lead, the cleanup of the manufacturing process will actually result in savings of $0.05 per round, or $20 million per year.

Stewardship sourcing

To avoid disruption by overharvesting, islanding or invasive alien species, a resource needs to be sustainably managed. Designers can support this by tracing the origin of raw materials, but this can be difficult. For example, it is easy in theory for you to develop a timber purchasing policy supporting sustainable forest management, but in practice it is difficult to verify the source of timber products.

The Marine Stewardship Council (MSC) uses a similar approach for the fishing industry. The MSC has a key role to play, as the fishing industry is extremely wasteful – the 'wrong kinds' of fish are thrown back to die in the sea, and the processing is very inefficient. One issue that needs more publicity is that of albatross bycatch. Now that driftnetting for tuna is banned or discouraged in many parts of the world, tuna is fished using rods and long lines. The albatross fly behind the boats, see the bait before it goes below the water, swoop down and are dragged underneath. It's a serious threat to some albatross species, yet all it takes to prevent it is a long scare-streamer to be fitted to each boat.

Think about your raw materials and find out about how they are harvested or extracted, particularly from overseas. Make an effort to go and visit suppliers. Also consider other ways in which the land that is used on your behalf can be better managed, for example by purchasing organic or biodynamic food, wool, cotton and leather.

1. The world's first FSC-certified copier paper from Dudley Stationery, England
Stewardship sourcing: Certification offers a solution which makes it clear which products have been grown according to specific standards that ensure sustainability. The Forest Stewardship Council (FSC) allows for the accreditation of forest assessors and the use of an FSC logo on products from certified forests.

2. Toyota's Prius hybrid electric car
Electricity: At any given moment, the Toyota Prius's onboard control systems choose between petrol, electric, both, none, or using braking energy to recharge the battery (known as regenerative braking). You don't plug it into the mains – battery charging is achieved via regeneration or by the petrol engine.

3. Powabyke electric bicycle
Electricity: The Powabyke overcomes the key drawbacks of ordinary bicycles – most people who work in an office find it a problem to arrive sweaty in their work clothes, or face problems with finding a place to change or shower.

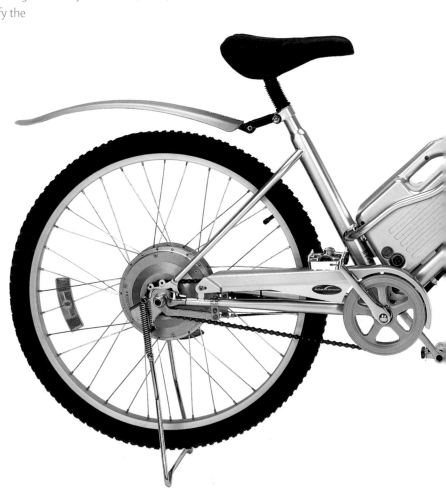

1

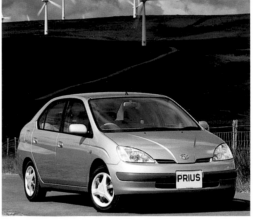

2

Electricity

Electric vehicles are zero emission at point of use, and their electricity will eventually all be provided by solar sources. In the UK, the Powabyke will zip through gridlocked city streets at a nippy 15 miles per hour and has a range of more than 20 miles. Electricity can also be used in combination with combustion. The Toyota Prius and the Honda Insight have a petrol engine, electric motor and battery.

Which materials are safe?

In many cases, we simply don't know which synthetic compounds are safe. The British Royal Society and the European Environment Agency both say that it would take thousands of years to properly test the toxicity of the 80,000 chemicals now in use.

Designers need to recognise just how many things are toxic. And also that the use of hazardous materials is standard practice. Unless you actively design out these hazards, using 'standard practice' will mean that your designs are helping to kill people.

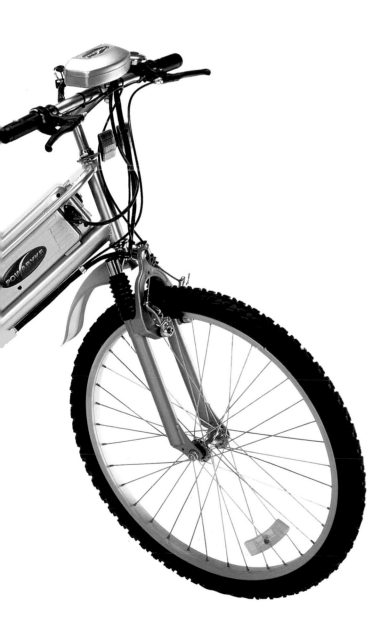

3

"Tom

orrow will be less"

Philippe Starck

Efficient:
Products in manufacture and use require 90 per cent less energy, materials and water than equivalent products did in 1990.

Many environmental improvements arise from an improvement in efficiency – if you have a washing machine that uses less electricity, then there will be less fuel burnt at the power station and so fewer emissions and less pollution. The same idea holds for materials use – less metal means less mining, and so on.

This concept, known as 'eco-efficiency', is very popular, perhaps because getting a job done using less energy means there is often a cost saving as well as an environmental benefit. And materials efficiency makes obvious sense for business, as it means you can sell the same chunk of stuff to more people.

Fewer materials

Despite the obvious benefits of efficiency, for many firms, 60 per cent or more of what they buy as raw materials is thrown away. Overall, the economy uses ten tonnes or more of materials for every tonne of product that is finally used by consumers.

There is a growing movement that believes we can be much more productive with the materials used by industry. The general view is that we can reduce energy and materials usage by 90 per cent, or by a factor of ten. This 'factor ten' approach is important and a huge challenge.

Efficiency is also a question of belief. Because it is such an obvious idea, everyone assumes that all the good efficiency measures are already in place. In fact, there are £20 notes and $50 bills lying around all over the place, just waiting to be picked up.

Control

Exquisitely fine control is found in the metabolism of living systems, and is something which maximises the use of materials. Making systems respond on demand is a way of improving efficiency.

Utility

The idea of utility is important here. It's about how much use or benefit a consumer gets out of a product. For example, a cheap suit might only last five years before it gets thrown out or recycled. A more durable suit might last ten years, so giving twice the utility to the user for the same quantity of materials. That's a significant improvement in efficiency.

So it's important to recognise what your product is actually delivering. The 'functional unit' of service is how different products can be compared. For example, a delivered litre of milk might be the goal, and you could use a returnable glass bottle or a paperboard carton to achieve that goal. Consumers don't necessarily want gas fires, light bulbs or TVs. They want heat, light and information.

1

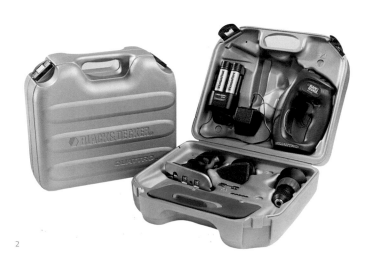

2

Multifunction

Having a product do more than one thing means it is more useful, and also avoids the materials impact of having to build two products.

Sharing and renting

A lawnmower is only used for 50 hours a year, meaning it lies idle for over 99 per cent of the time. If it could be shared among more people, the utility would be much higher. Sharing, renting and libraries are excellent routes to environmental improvement.

Information technology is making sharing and rental schemes more possible. In Switzerland, the Mobility car sharing scheme is very successful. Co-owners book a car and also use smart cards to keep track of vehicles and as keys to the doors. Toyota's Crayon electric cars have GPS built in and this information is radioed automatically to a central computer which can tell sharers where the nearest car is and when it will become available.

1. No-Shank minimalist toothbrush
Fewer materials: The design of the No-Shank finger toothbrush eliminates the need for a handle. Weighing just 1.3g with no packaging it's perhaps an 80 per cent reduction in product mass.

2. Quattro multifunction power tool by Black & Decker
Multifunction: The Black & Decker Quattro is a power tool with changeable heads. This allows it to be a drill, screwdriver, saw and sander all in one, a saving of three electric motors and power units.

3. Trippen's Cham variable heel shoes
Multifunction: Trippen make rubber sandals in a '60s style with interchangeable heels. A low heel for day wear and a high heel for evening wear. Each pair comes with both high and low heels, which are simple to change.

4. Tripp Trapp growing chair
Multifunction: The Tripp Trapp chair is a cleverly designed wooden chair that starts as a highchair, transforms to a toddler's seat and finishes as an adult's chair.

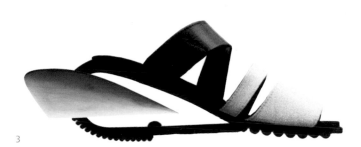

3

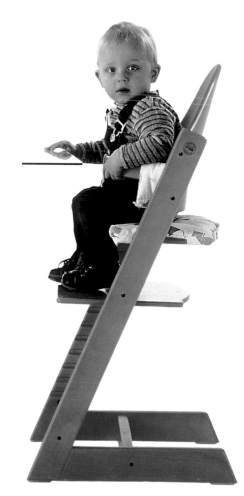

4

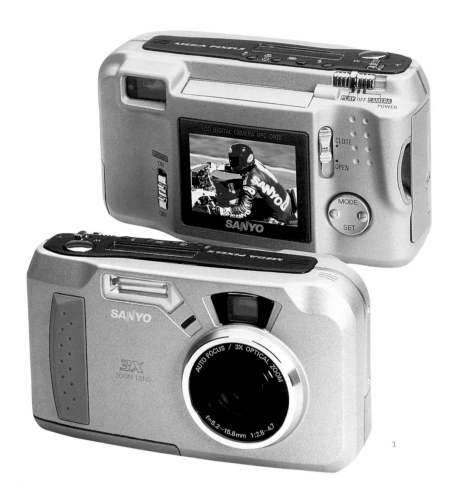

1

Be more local

Local sourcing reduces transport impacts and cost. It can also stimulate the local economy, helping local sales of your own products. Many goods are transported remarkable distances, even during processing, such as cars which are sent to Italy and back for special features to be added. Another example is 'Food Miles', where food either travels a long way, such as from the other side of the world in the case of New Zealand lamb or apples. Remember this as the 'proximity principle'.

Durability

There has always been the story about the light bulb that never wears out. If it did exist, it might well be more expensive than most consumers were willing to pay. So there you have the fundamental problem with making durable products. One way round this would be to lease or rent the product, something which encourages the manufacturers to make durable products so they don't have the expense of replacing them.

In general, durability equates with the high end of the price spectrum, and is a characteristic of luxury goods. However, there are engineering solutions that do allow for high durability at low manufacturing cost.

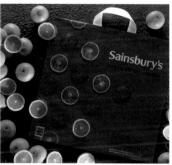

2

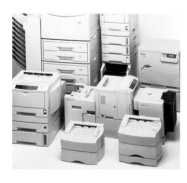

3

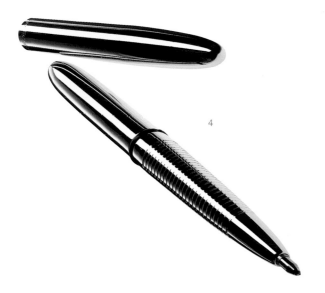

4

Upgrade and repair

Another aspect of durability, but distinct from it, is the tendency of consumers to want the latest model of a product. This usually requires the replacement of a product, but if it can be engineered to be upgradable, then the life of the original product can be extended.

For example, telephones can have a removable outer casing and buttons, allowing for changes in style and fashion while retaining the internal workings. Many personal computers have been designed to allow the upgrading of the PCU, the RAM, hard disk, graphics card, and so on, often with easy access ports and slots so the end-user can perform DIY upgrades.

Thinking a thousand years ahead

All products are disposable in the end, so firms should always plan for end-of-life or takeback even if it will happen in 20 or 50 years.

The architects of Jesus College Cambridge over 300 years ago realised that a major oak beam would eventually succumb to rot. When this occurred in the 1980s, the college looked back at the records and realised that the architects had planted a suitable oak tree on college land which was by then big enough to replace the original beam.

1. Digicam 400 SolarCam by Sanyo
More local: Sanyo's Digicam 400 SolarCam generates electricity locally and in proportion to need. The screen is the part of a digital camera that uses the most energy. The brighter the day, the brighter the screen needs to be for proper viewing. So having a solar booster makes a lot of sense.

2. Bag for Life by J. Sainsbury
Durability: A 'Bag for Life' is being tried by UK supermarkets such as Waitrose, Tesco and Sainsbury in order to try and reduce the amount of disposable plastic shopping bags used. The customer purchases a specially sturdy plastic bag for 10p and uses this for shopping, and if it wears out, the bag is replaced for free. The Bag for Life weighs about five times the weight of a disposable bag, is about one and half times as big, and may last a year, so replacing 75 bags, a 93 per cent saving.

3. Ecosys long-life printer by Kyocera
Durability: Kyocera make toner-only laser printers with a long-life drum, unlike most other types of printer, where both the drum and toner are replaced each time.

4. Millennium II Spacepen
Durability: The Spacepen Millennium II range contains 30 miles of ink, enough for a lifetime of most people's writing. This eliminates the need for refills.

5. Sri Swaminaryan Hindu Temple in London
Durability: The architects of the Sri Swaminaryan Hindu Temple in Neasden, London, used only marble and no steel for their building. This is because after about 300 years, steel and stone start to make a chemical reaction and become weak. This was no good for a building designed to last a thousand years. Now that's durable!

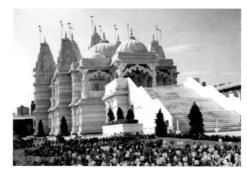

5

"cannibals wi

John Elkington

th forks"

Social:
Product manufacture and use supports basic human rights and natural justice.

Human capital is our most valuable resource, and so we should look after it. Exploitation and maltreatment of our fellow man is unsupportable, yet companies do it all the time because such abuse is hidden to the end-user. Do we deliberately design our products so that they involve child labour and unsafe working conditions? Of course not. But unless we use our influence in the design process to actively design these problems out, they will still be there. The social aspects of the product lifecycle must be considered by designers.

People

Unfortunately, workers are all too often treated badly. A totally beautiful product will have been made by people who are living a decent life and are treated fairly. So the social requirement means checking working conditions all the way up the supply chain – which is something of a recurring theme in sustainable product development. You have to know where materials and components are coming from and how they are being made.

The principles of SA8000

For the details of exactly what 'natural justice' entails, I have adopted the principles of the SA8000 standard, which is based on a consensus on what organisations working in this area think is important. It's also based on the conventions of the International Labor Organization, the Universal Declaration of Human Rights and the UN convention on the Rights of the Child.

SA8000 specifies that, at a minimum, companies should:

• not engage in or support the use of child labour;
• provide adequate support to enable such children to attend and remain in school;
• not engage in or support the use of forced labour;
• provide a safe and healthy working environment and ensure that all personnel receive regular and recorded health and safety training;
• respect the right of all personnel to form and join trade unions of their choice and to bargain collectively;
• not engage in or support discrimination in hiring, compensation, access to training, promotion, termination or retirement based on race, caste, national origin, religion, disability, gender, sexual orientation, union membership, or political affiliation;
• not allow behaviour, including gestures, language and physical contact, that is sexually coercive, threatening, abusive or exploitative;
• not engage in or support the use of corporal punishment, mental or physical coercion, and verbal abuse;
• not, on a regular basis, require personnel to work in excess of 48 hours per week and provide them with at least one day off for every seven day period;
• ensure that overtime work does not exceed 12 hours per employee per week, is not demanded other than in exceptional and short-term business circumstances, and is always remunerated at a premium rate;
• ensure that wages paid for a standard working week shall meet at least legal or industry minimum standards and shall always be sufficient to meet basic needs of personnel and to provide some discretionary income; and
• comply with prevailing laws, regulations and other applicable requirements.

To make sure that these principles are not just a piece of paper, the 'plan, do, check, act' management system concept underpins SA8000, requiring executive responsibility, control, and continuous improvement in performance.

1

1. & 2. Auro paints

Fairtrade: Auro are based in Braunschweig, Germany, and their raw materials include linseed oil which is mostly from organic sources and all from within 20 miles of the factory, which supports the local economy, and Dammar resin, fairly sourced from tapping a tropical tree. This non-destructive harvesting provides sustainable exploitation of the forests, and the direct contact with the local suppliers gives its inhabitants a secure source of income.

3. Wilkhahn staff room

Fairtrade: It's not just about meeting minimum standards. Furniture manufacturer Wilkhahn is a company which practices fairness and co-operation. Its employees have a 50 per cent share in operating profits, and there are only two management levels, giving everyone the chance to participate in decisions.

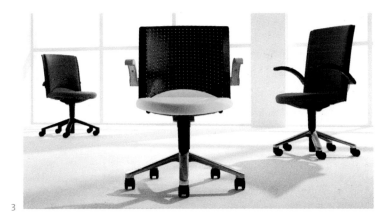

3

2

The Fairtrade Foundation

The Fairtrade Foundation exists to help producers in developing countries receive a fair share of the money made by their products. Whenever you see the Fairtrade mark on a product, it's a guarantee that the people who produced it have received a fair price and a fair deal. Fairtrade status has been given to various coffees, chocolates, orange juice, tea, honey, sugar and bananas. The principle is also applied more broadly, without independent certification, by firms such as Auro who source resin from tapping the tropical Dammar tree.

Imagine a piece of paper that travels with the product like a job sheet. The piece of paper is signed by everyone who touches the product as it is made – the copper miner, the merchant seaman, the factory worker, the shelf stacker, the checkout girl, the actual consumer, the rubbish collector and the waste dump operator. This entire journey is defined by your design, and it will come under scrutiny by consumers. Are you proud of every step?

thi

It's not just about recycled paper and washing powder...

...it's about redesigning

every-

ng

THE TOTAL BEAUTY OF A SUSTAINABLE DAY

The Total Beauty of a Sustainable Day

What would a typical day look like when products were designed with total beauty in mind? What follows is a story that uses some of the best products that are available today. None of them are 100 per cent cyclic, solar and safe. In fact, far from it in some cases. In particular, given carte blanche I would be using all local products, but that would have been a less interesting story.

Ecological house

The Hockerton Housing Project is the UK's first earth-sheltered, self-sufficient ecological housing development. The residents of the five houses generate their own clean energy, harvest their own water and recycle waste materials causing no pollution or carbon dioxide emissions.

The houses only use ten per cent of the energy used by a conventional house. A wind turbine is being set up to provide renewable electricity. They have no central heating, as heat losses are balanced by the heat given off by the residents (each person provides 100W of heat) and passive solar gain via the conservatory. The whole construction acts like a giant storage radiator, slowly absorbing and releasing heat.

Hot water is provided from large water storage containers heated via a heat pump that captures heat from the conservatory. The hot water tank acts as an energy store, being able to supply hot water for up to six days without the need for heating.

The houses are self sufficient in water, by collecting rainwater from the conservatories, and using showers instead of baths.

"I awake to the sun streaming in through the conservatory of my ecological house."

The houses are partly buried under 500 tonnes of earth, which acts as a temperature buffer, as soil temperature lags behind air temperature by three months. Thick insulation throughout drastically cuts heat loss.

The architects, Prof. Brenda and Dr Robert Vale, also added a ventilation system that captures 80 per cent of the heat from extracted air, which is used to warm the cooler incoming air.

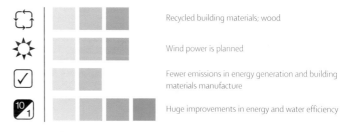

Recycled building materials; wood

Wind power is planned

Fewer emissions in energy generation and building materials manufacture

Huge improvements in energy and water efficiency

(Baseline: UK four-bedroom 1990s' house)

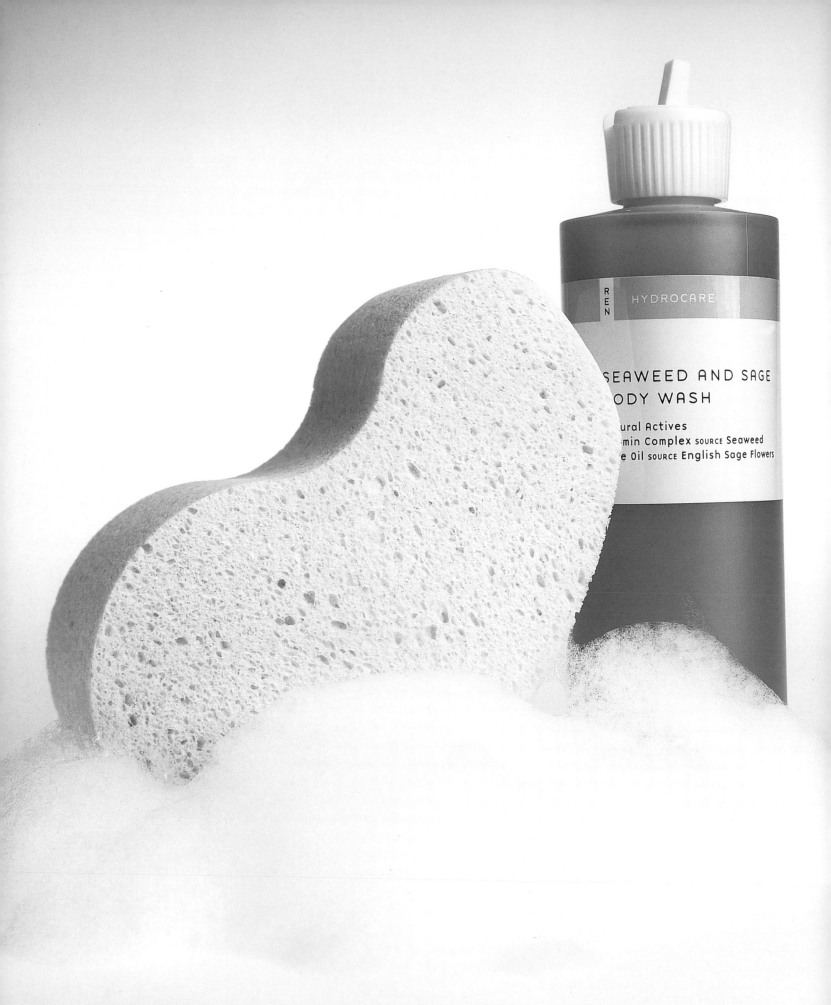

"I step into the shower, and reach for the body wash."

REN Seaweed and Sage Body Wash

REN pay particular attention to their ingredients, and this is their main source of environmental innovation.

Their products are free from: mineral oils, paraffin and petrolatum that block pores and stop skin breathing freely; sulfates such as sodium laureth sulfate and other harsh detergents that can strip the skin of its natural oils leaving it dry and prone to irritation; animal ingredients such as lanolin, collagen and elastin; GM ingredients; propylene glycol; DEA and TEA, commonly used pH buffers that can react with other ingredients to produce carcinogenic by-products; and parabens, which are commonly used preservatives that can cause sensitivity.

Instead, REN have used coconut and oat-based detergents, seaweed, and English sage flower oil as their main ingredients.

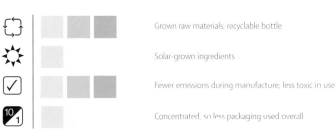

Grown raw materials; recyclable bottle

Solar-grown ingredients

Fewer emissions during manufacture; less toxic in use

Concentrated, so less packaging used overall

(Baseline: Standard shampoo)

"I wander into the kitchen and set about getting breakfast."

Ridgways' organic Fair trade tea

Ridgways' organically grown tea is sourced from plantations in Southern India and Africa. These plantations are certified as being organic by the Soil Association and the Organic Farmers and Growers, guaranteeing that no pesticides are used.

It's also got the Fair trade mark. The Fair trade Foundation exists to help producers in developing countries receive a fair share of the money made by their products. Whenever you see the Fair trade mark on a product, it's a guarantee that the people who produced it have received a fair price and a fair deal.

Ridgways also backs this up with regular inspections of its plantations to ensure that there is no compromise on product quality or on working conditions for tea pickers and their families. This includes strict standards which are maintained with regard to housing, education, healthcare and pay.

I boil the water in a low-energy electric kettle, measuring out only the amount I need by simply filling my mug with cold water and emptying it into the kettle.

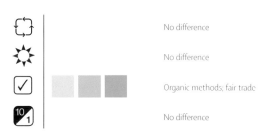

		No difference
		No difference
		Organic methods; fair trade
		No difference

(Baseline: Mass-market Indian tea)

Sony wind-up radio

The Sony ICF-B200 is really designed to be an emergency radio. Equipped with a power generator, it needs no batteries.

Rotating the handle for one minute produces roughly 8mAh of power, enough for 30 minutes of FM reception. With a full charge, equivalent to about 30 minutes of winding, the radio will operate for about 20 hours.

The plastic housing is not recycled but the parts are labelled for recycling. The electronic components are standard.

For a radio of this size, only about 50 per cent of total lifetime energy is consumed during use. So while I am using muscle power to run the radio, half of the energy involved in this product was used during manufacture, and this was not renewable energy at all.

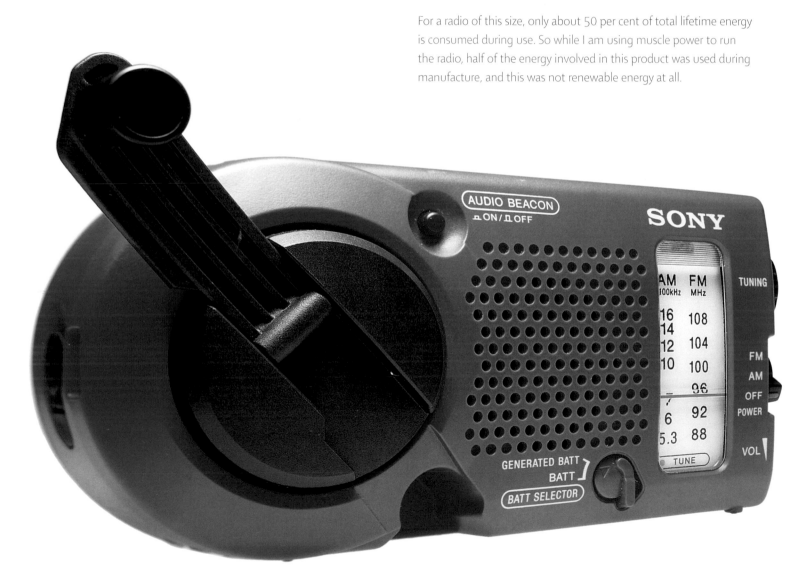

"Refreshed by the caffeine, I pick up the radio and give it a few winds so I can listen to the news."

It contains a Nickel Cadmium rechargeable battery inside, and this has its own impacts and gives the product a limited life – maybe ten years. This means that the radio is better than using disposable batteries, but probably not better than a mains-powered one.

The ICF-B200 uses about the same quantity of materials as an ordinary radio. However, if you compare it with a disposable battery radio with the 180 AA batteries (nearly 4kg) that would be used over its expected life, then the Sony uses significantly fewer materials.

Same degree of recyclability as any radio

Solar powered in use but not manufacture

No battery wastes

Less lifetime mass as no batteries

(Baseline: Battery-operated radio)

"I reach for a bowl and pour myself a hearty serving of organic muesli."

OAO organic muesli

OAO muesli is from a range of organic foods created by Philippe Starck. As Starck says, "We are what we eat. Man is an ecosystem in which spirit is connected with the body and its nourishment."

The biological integrity of OAO's products is guaranteed by the control of the laboratory Lima and is certified by Ecocert.

Organic agricultural products are cultivated without fertilisers and chemical products. In Europe, all the participants in organic production are certified and submitted to regular controls by an independent inspection body that is itself accredited. These controls are taken seriously. In Denmark, if a company is found to be cheating with its organic products, the management is reported to the police and can face fines or imprisonment or a ban from producing or selling organic products for up to five years.

No difference

Manure and compost used instead of synthetic fertilisers

Organic growing methods

No difference

(Baseline: Standard muesli)

Organic soy milk

Provamel Organic is made in Belgium from filtered water and hulled organic soya beans. And that's it.

The organic status in this case is controlled by Ecocert in Belgium. Provamel also ensure that their products are GMO free by using full traceability and testing by independent labs. With so many genetically engineered soya beans on the market, particularly in the US, it's important to have an audited paper trail that tracks the beans and the seeds they were grown from.

Soya contains the same amount of protein as dairy milk, in addition to which it provides all eight of the essential amino acids which the human body is unable to produce naturally. It's also rich in polyunsaturated fatty acids and is naturally free of cholesterol. Compared to semi-skimmed cow's milk soya contains much lower levels of saturated fat.

" **Then I splash on some organic soy milk.** "

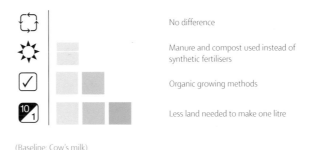

No difference

Manure and compost used instead of synthetic fertilisers

Organic growing methods

Less land needed to make one litre

(Baseline: Cow's milk)

"I throw the used tea bag in the Can O' Worms and the carton in the Ecobin."

Can O' Worms

The Can O' Worms organic waste processor is "the world's first domestic continuous cycle composter". It stacks vertically and material rots down and is moved progressively downwards until it reaches the bottom bin and can be put on the garden.

Composting is by far the best thing you can do with organic waste.

Compost creation

Makes use of direct solar heating

No dumping

No waste collection and so no fuel

(Baseline: Waste bin)

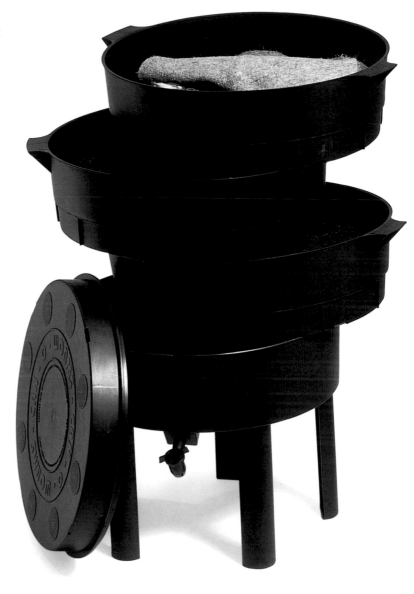

Ecobin

The Ecobin is a simple, heavy, wire structure that holds old plastic shopping bags. You can operate it as a pedal bin.

I use it for non-recyclables, as I have separate boxes for glass and aluminium in the cupboard under the sink.

 Re-use of plastic shopping bags

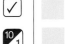 No solar power used in use or during manufacture

Fewer toxic releases as fewer plastics manufactured

Fewer materials used

(Baseline: Plastic pedal bin)

Foxfibre organic cotton socks

The socks are made from Foxfibre, an organic, inherently coloured cotton, based on green, brown and rust-coloured wild varieties, so needing no dyes at all. Coloured cottons have always existed in nature. Native peoples have used their short fibres for hand-spinning and weaving.

A breeding programme was initiated to select coloured cotton with improved fibre and agronomic characteristics that could be grown organically, achieving success in 1989.

Available in reddish brown, bronze-brown and green, all varieties have good fibre length and some are inherently flame resistant. It's also up to 20 per cent cheaper, as, although the fibre is more expensive, the cost of dyestuff, energy, water, and toxic dye waste disposal is eliminated. All Foxfibre varieties share a unique property – their colour intensifies with washing (and presumably doesn't run and ruin your whites).

" Time to get dressed. I put on my socks, which are made of naturally-coloured cotton. "

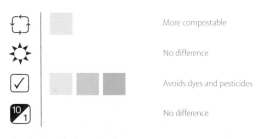

More compostable

No difference

Avoids dyes and pesticides

No difference

(Baseline: Standard cotton socks)

"I find my shoes, which are designed to be repairable and recyclable."

Trippen shoes

Haferl shoes are made by German company Trippen.

The upper part of the Trippen shoe is sewn to the removeable sole twice – first to the between sole and then to the rubber sole itself. The function behind this unusual technique is to make the soles easily exchangeable and recyclable.

The pre-moulded cork insoles are anatomically formed to support the foot, and help against back and hip problems. The insoles can be sanded down to make a perfect fit.

All material that comes into contact with the foot is made of 100 per cent vegetable tanned leather.

Recyclable design

No difference

Less pollution from leather tanning

Longer product lifetime from repairability

(Baseline: Leather upper, rubber-soled shoe)

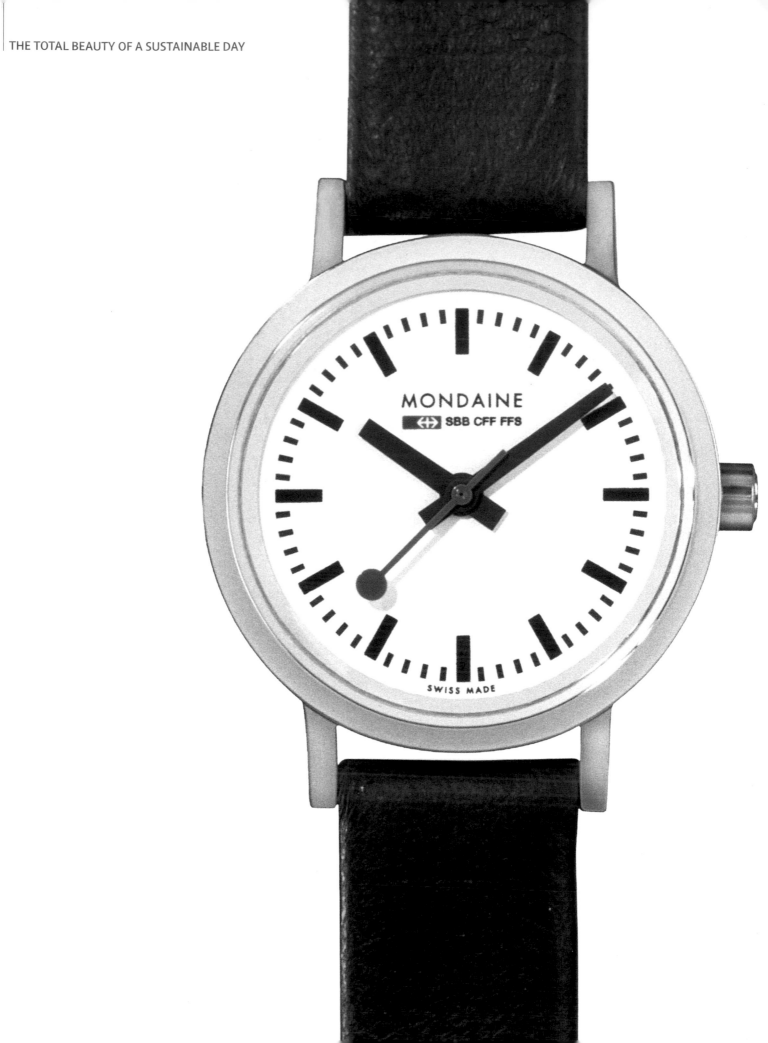

"Time's getting on, so I check my Mondaine Ecomatic watch to make sure I won't be late for work."

Mondaine Ecomatic

As we have seen, the rarer metals often used in watches, like gold and titanium, have huge impacts during extraction. The Mondaine Ecomatic aims to address this.

The watch is made from cyclic materials with its leather strap and 100 per cent post-consumer brass case, verified as recycled by a Swiss Institute.

The automatic movement naturally uses no batteries and is repairable and potentially recyclable, although at the moment such movements are usually just cannibalised for spare parts.

Thus the watch can be almost entirely recycled at the end of its life, albeit with the leather being compostable over 30 years.

Because watches use so little energy to turn the hands around, about half the lifetime energy of a watch is used during manufacture. As about 20 per cent of energy in Switzerland is from renewable sources, and as the energy that drives the watch is solar via human muscle power, we can say that the watch is 60 per cent solar-powered.

Grown materials for strap; recycled and recyclable case and mechanism

Solar-powered through wrist movement

No battery disposal but chrome plating

Less lifetime materials mass as no batteries, plus longer life

(Baseline: Quality Quartz watch)

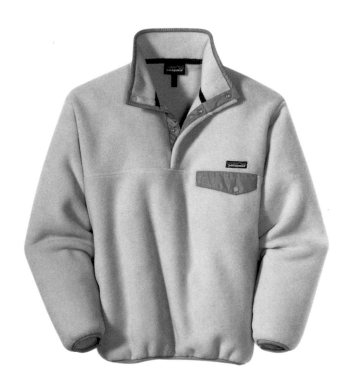

"I put on my Patagonia fleece top made from recycled plastic soda bottles."

Patagonia fleece

Patagonia use a 90 per cent post-consumer recycled (PCR) polyester in many of their fleece garments.

The collected bottles are flaked and baled and then spun into a fibre that has the same soft feel and lustrous colour as virgin fleece but which hurts the environment far less.

Since 1993, Patagonia has diverted over 100 million plastic soda bottles from landfills, which saved over a million gallons of oil from being used and avoided 13,000 tonnes of toxic air emissions. To give you an idea of the problem: plastic packaging accounts for 11 per cent of US solid waste. Of the nine billion bottles sold each year only a third get recycled. The rest still goes into landfills; 60 billion bottles every ten years.

The wind-powered factory adds to the good environmental performance of this product.

Patagonia also have a commitment to durability and lifetime extension, saying, "We encourage our customers to do their part to help the environment by buying only what is needed, wearing it out or passing it on to charities for redistribution."

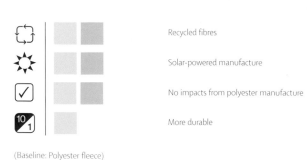

♺			Recycled fibres
☼			Solar-powered manufacture
✓			No impacts from polyester manufacture
10/1			More durable

(Baseline: Polyester fleece)

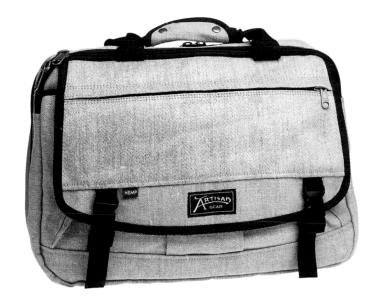

"I grab my Artisan hemp briefcase and head out of the door."

Artisan hemp briefcase

This briefcase is made of hemp, which is several times stronger than cotton; more resistant to abrasion and tears, to mildew, soiling, shrinkage and the deteriorating effects of the sun. Hemp actually improves soil fertility and requires no dangerous pesticides in cultivation. Hemp produces three times as much fibre per acre as cotton.

Nylon webbing straps have been used for elements that are under tension, like the handle and strap.

When my briefcase eventually wears out, I will return it to Artisan and they will recycle it and send me a coupon good for 15 per cent off my next Artisan product. They also donate three per cent of profits towards environmental preservation.

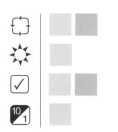

Grown materials; compostable; takeback scheme

Solar-grown raw material

Fewer emissions in manufacture; fair trade

Good durability

(Baseline: Standard nylon briefcase)

TH!NK electric car

For my daily commute, I use a Norwegian car called the TH!NK city.
It has a range of 100km, which is fine as work is only 15km away. In the
evening, I just plug the car into a standard socket in the garage and by
the morning it's all ready to go again. And electricity is a cheap form of
fuel – I pay the equivalent of 50 cents a gallon.

The TH!NK has a continuous automatic transmission. Top speed
is a nice 90km/h or 56mph, fine for urban or suburban driving.

It also uses Nickel Cadmium batteries which weigh 250kg and are
placed under the seats. The batteries last for ten years. I'm not wild
about the use of something as toxic as cadmium, but hopefully the
next generation of electric cars will be using Nickel Metal Hydride or
lithium ion cells instead.

The TH!NK city needs a service only once a year, a common feature
of electric vehicles, as electric motors can last up to 90 years. And
obviously, there are no exhaust pipes, spark plugs or oil changes
needed. It's also simpler to maintain because it's made of 450 parts,
considerably fewer than other cars.

Because the rear tailgate is entirely glass, I can see right down to the
bumper of the car behind, making it easy to park.

Slightly less recyclability due to battery

Solar-powered charging is possible

A net overall reduction in lifetime toxic releases

Small improvement in overall energy efficiency

(Baseline: 1999 VW Polo)

"I stop at the traffic lights in my noiseless electric car."

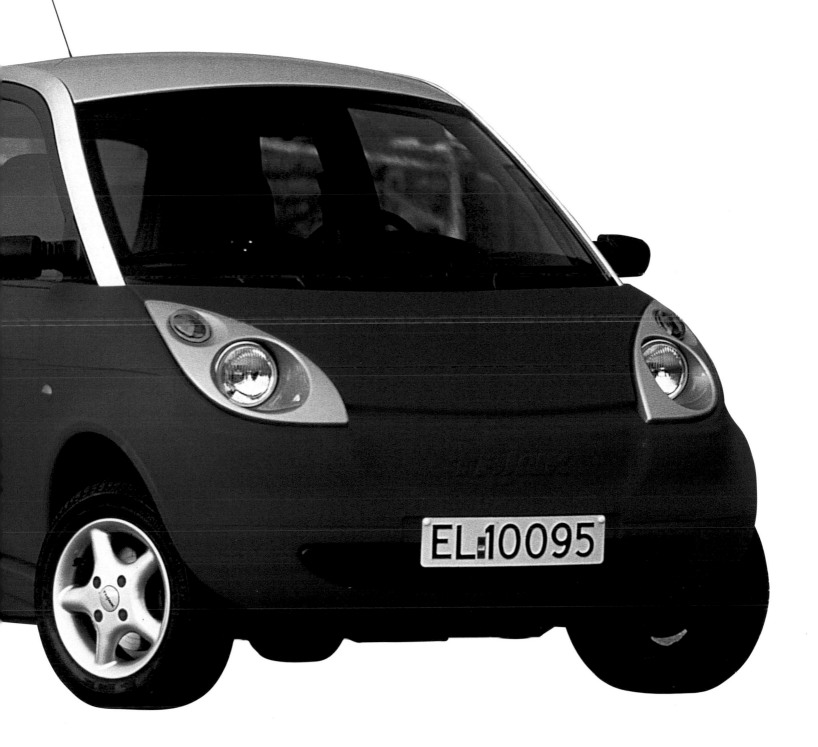

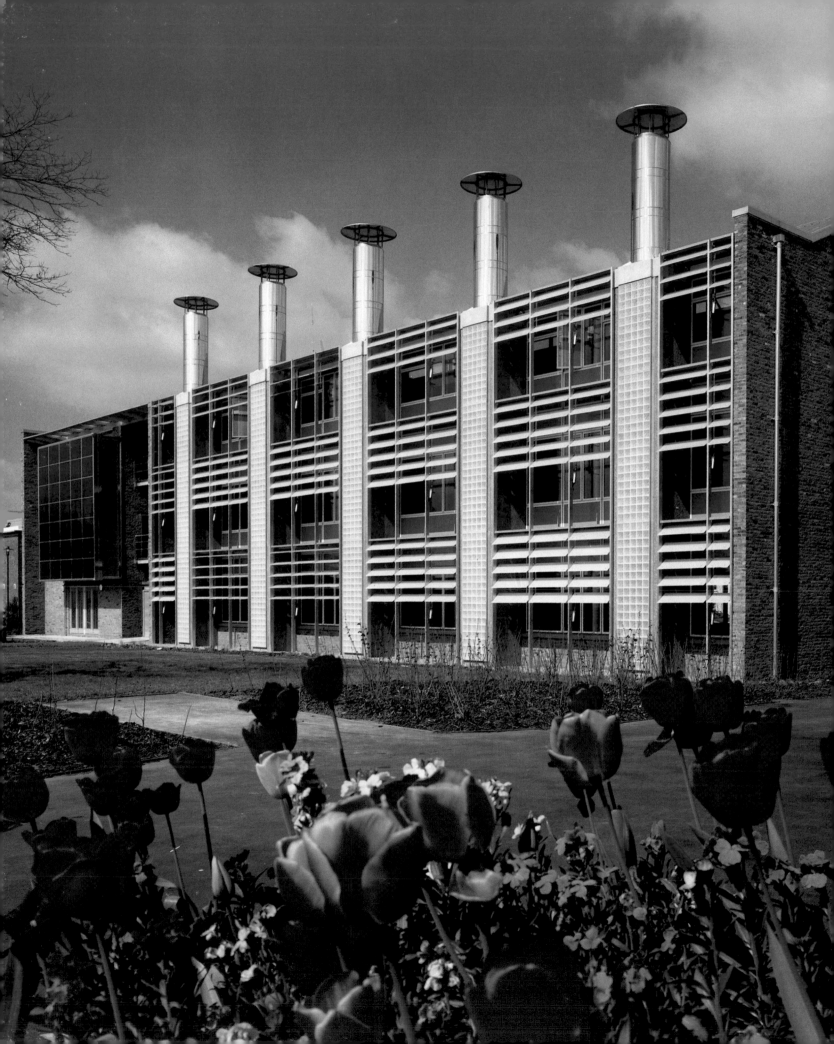

"As I near work, I can see the distinctive ventilation shafts of my office protruding above the trees."

BRE Environmental Building

My office, which in real life is the BRE Environmental Building at Garston, England, was designed by architects Feilden Clegg of Bath who were asked to use natural ventilation, maximum use of daylighting, maximum use of the building's mass to moderate temperature, and controls that would let the building meet its environmental targets but keep its occupants happy.

Air conditioning – the major energy consumer in many existing office buildings – is not used. Other savings will be made by making better use of daylighting and by using the building's 'thermal mass' to moderate temperatures.

Working rather like a greenhouse, the summer sun shines into the glass-fronted shafts, warming the air inside. This warmed air naturally rises out of the stainless steel 'chimneys' and causes air from inside the building to be drawn through to replace it. On a breezy day the movement of air across the tops of these chimneys increases this 'stack' effect. On very warm, still days low-energy fans in the tops of the stacks can be turned on to give greater airflow. Overnight, the control systems can open ventilation paths right through the concrete slab to cool it further, storing this 'coolness' for the following day.

To make maximum use of available daylight the building has a large glass area, carefully optimised to provide high light levels but low heat losses and solar gain. To prevent excessive heating and glare from the sun shining in – the 'blinds down, lights on' situation common in many offices on sunny winter days – the building has a system of Colt motorised glass louvres on the south façade to control the daylighting levels.

The south façade features a photovoltaic array, providing additional power to the building from a non-polluting source.

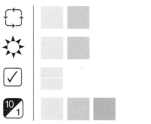

Re-used building materials

Solar-powered in use

Fewer toxic releases; better wood sourcing

Less embergy, energy, water, and materials

(Baseline: Standard UK office building)

"I sit down on my Aeron chair and get to work."

Aeron chair

When designing a product, it's a basic data requirement to keep track of what percentage of a product by mass is composed of recycled parts. For example, my Aeron office chair by Herman Miller has 67 per cent recycled parts, mostly achieved by the use of 100 per cent recycled aluminium, which makes up much of the weight of the chair.

The chair has no organic materials. It is, by weight, two-thirds recyclable. All plastic parts are labelled according to ISO recycling symbols. The most valuable part for recycling, the aluminium leg base, is easily disassembled.

Recycled or secondary aluminium is about 95 per cent better than virgin across the impact areas of energy, materials, water and air.

A further innovation is the use of a suspended trampoline-like seat and back, which dematerialises the conventional wood, foam and fabric upholstery.

It may be 40 per cent heavier than a standard chair, but it has a ten-year design life, probably double that of a cheap chair. So in materials terms, the Aeron is more efficient. It's also repairable, unlike cheap chairs; you can find broken cheap chairs out the back of most office blocks.

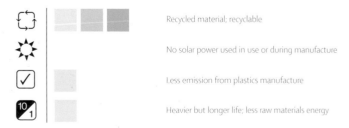

Recycled material; recyclable

No solar power used in use or during manufacture

Less emission from plastics manufacture

Heavier but longer life; less raw materials energy

(Baseline: Equivalent plastic, foam and steel chair)

"My desk is made from recycled newspapers and soya."

Phenix Biocomposite desk

By utilising annually renewable, sustainable and recycled resources, Phenix Biocomposite has created a line of products that deliver better value to the marketplace and which are alternatives to forest products.

My desk is made from Environ Biocomposite, a decorative interior material that respects the environment by using recycled paper products, a soy-based resin system, and colour additives. The material has a unique and elegant appearance combined with the warmth and feel of an exotic hardwood. The material is one-and-a-half times harder than oak, but can be cut, milled, routed, drilled, fastened and finished similar to wood.

The rich colour and random pattern run throughout the thickness of the material. Compared with wood, Environ is lighter in weight – from 5 per cent to 15 per cent; has smoother surface characteristics; has good moisture resistance and is formaldehyde-free.

Each tonne of recycled newsprint used in Environ conserves three cubic yards of landfill. Phenix claim that recycling this type of material uses 70 per cent less energy and decreases air pollution emissions by up to 73 per cent.

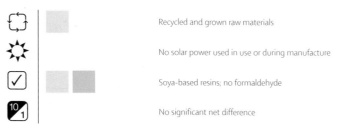

Recycled and grown raw materials

No solar power used in use or during manufacture

Soya-based resins; no formaldehyde

No significant net difference

(Baseline: Steel and chipboard and veneer desk)

Cornstarch pen

Except for the ink refill, the Green Pen is made from Mater-Bi, a material derived from cornstarch and made by the Italian company Novamont.

Mater-Bi is remarkably similar to ordinary plastic, with one important exception: it is completely biodegradable. This means that unlike conventional plastics which never break down, Mater-Bi products will disintegrate in about 12 months after being thrown away.

Plastified starch materials exhibit mechanical properties similar to conventional plastics such as polypropylene, and are generally resistant to oils and alcohols. However, they degrade when exposed to hot water, although I have stirred my tea with the Green Pen and found no ill effects.

At the end of its life, my pen can be composted, but only if the user is aware of its properties. If incinerated or landfilled, then it will be converted into CO_2 and H_2O (with some methane if in landfill) which also will be cyclic but that would be perhaps not as useful as contributing to soil.

"I jot down a few notes with my bioplastic pen."

Some models of this pen come with some wildflower seeds encased in the end, so that the pen can simply be stuck into soil, and flowers will sprout from it.

			Grown and compostable
			Solar grown but fossil-driven manufacture
			No emissions from oil refinery
			Fewer ink miles per pen

(Baseline: Plastic disposable pen)

Furnature chair

Furnature is a Boston company that makes a range of chairs, sofas, pillows and beds. The sofas come in six classic styles and look like 'normal' furniture.

All frames are untreated, kiln-dried, hard rock maple. The legs are an integral part of the frame, and joints are double-doweled and glued with water-based glue.

It has an organic cotton underlayer and organic cotton batting over a woven steel base. All loose cushions have an organic cotton muslin cover.

Broadly speaking the fabric and wood are both biodegradable and recyclable, and the steel is recyclable. It is unlikely that they use pure secondary steel made from 100 per cent scrap, so the steel is probably 20 per cent scrap. With no take-back scheme indicated, any recycling is left to the consumer.

These chairs are "designed for chemically sensitive individuals, and contain no foams, polys, or formaldehyde...nothing synthetic!" All materials are biocompatible, and you could put this on your compost heap. Furnature says that, "all cotton batting used in Furnature has been certified 'organic' by the Department of Agriculture".

The efficiency of manufacture and energy and materials use is about the same as any other chair (unlike the inflatable SoftAir range, which is 95 per cent dematerialised compared with upholstered equivalents). The Furnature chair may give more utility as it may last longer than some sofas. Furnature say their frames are "constructed to be passed on from one generation to the next".

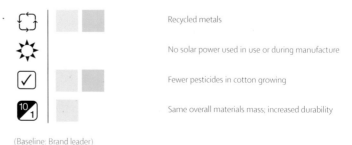

Recycled metals

No solar power used in use or during manufacture

Fewer pesticides in cotton growing

Same overall materials mass; increased durability

(Baseline: Brand leader)

"My colleague Yolanda drops by for a gossip. She tells me about a new chair she bought for her house, called Furnature."

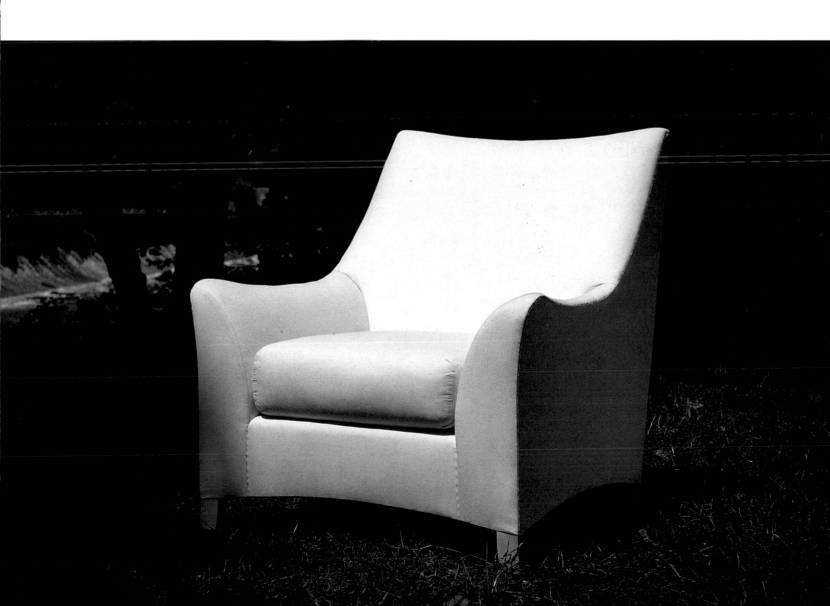

"I get Yolanda a coffee. We have found a new solar-dried brand from Costa Rica."

Solar coffee

Coffee growing is the second greatest cause of rainforest destruction after cattle ranching, because trees are cut to grow and dry the freshly-picked coffee crop. To address this, our coffee is solar-dried, organic, green coffee from the co-operative Montes de Oro, in the province of Punarenas, Costa Rica.

Montes de Oro is the first coffee producer to incorporate Solar/Biomass coffee drying systems that use renewable energy to dry coffee. A solar dryer is a state-of-the-art, low-temperature drying machine that reduces the moisture content of green, freshly picked coffee beans to 12 per cent and makes the small farmers' product export-ready. Solar thermal collectors provide heat for drying, while photovoltaic panels produce electricity for fans, computer controls and community lighting.

The co-operative strives to adhere to the principals of economic profitability and social environmental sustainability.

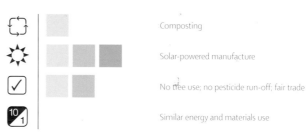

Composting

Solar-powered manufacture

No tree use; no pesticide run-off; fair trade

Similar energy and materials use

(Baseline: Conventional grown beans)

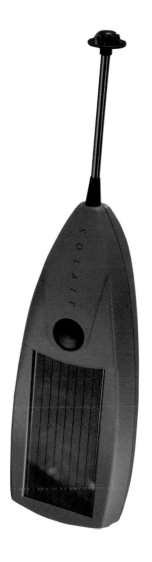

> " I whisk the milk with our solar-powered milk frother."

Solait milk frother

This is a delightfully ambiguous product example. The Solait is a solar-powered milk frother. The manufacturers specially developed the propeller blades with 'anti-spray contouring', allowing hot milk to be turned into firm, frothy cream in just ten seconds.

We leave it hanging up in the window of the office kitchen during the day to charge the battery, so the Solait is always ready for use.

It's undoubtedly better than a battery-powered model would be. But I've never seen a battery-powered portable milk whisk before, so I'm not sure this is really a good baseline. There are perfectly functional hand whisks, including ones made from just bamboo, which would be very sustainable indeed.

But there are millions of coffee lovers who are not so strong with their hands, perhaps suffering from arthritis, for example. These people have a legitimate need for a powered device. But even then, a direct mains-powered unit would mean no rechargeable battery or solar panel need be manufactured.

Less recyclable due to battery and PV cell

Solar-powered in use

Avoids emissions from power stations, but has battery toxicity

Not any more efficient in energy use

(Baseline: Mains electric whisk)

Remarkable pens and pencils

A typical office worker gets through 20 to 30 pens and pencils a year. It seems that a lot of them go walking, lie unused in drawers, or malfunction in some way, so the best way to improve their environmental performance is to hang on to them and use them all up. However, you can also get recycled pens and pencils as well.

"The pencil my friend is using has the words 'made from one recycled vending cup' stamped on the side."

The Remarkable pencil is made in the UK from recycled vending cups. The polystyrene is melted down and formed into a long tube around a graphite core. The pencils are then chopped to length and they can also be printed on the side.

Some people would argue that plastic cups are unnecessary in the first place, so these pencils offer no real advantage, but pragmatically they are diverting a real waste stream.

Recycled; recyclable

No solar power used in use or during manufacture

Avoids emissions from plastics manufacture

More miles per pencil

(Baseline: Standard pencil)

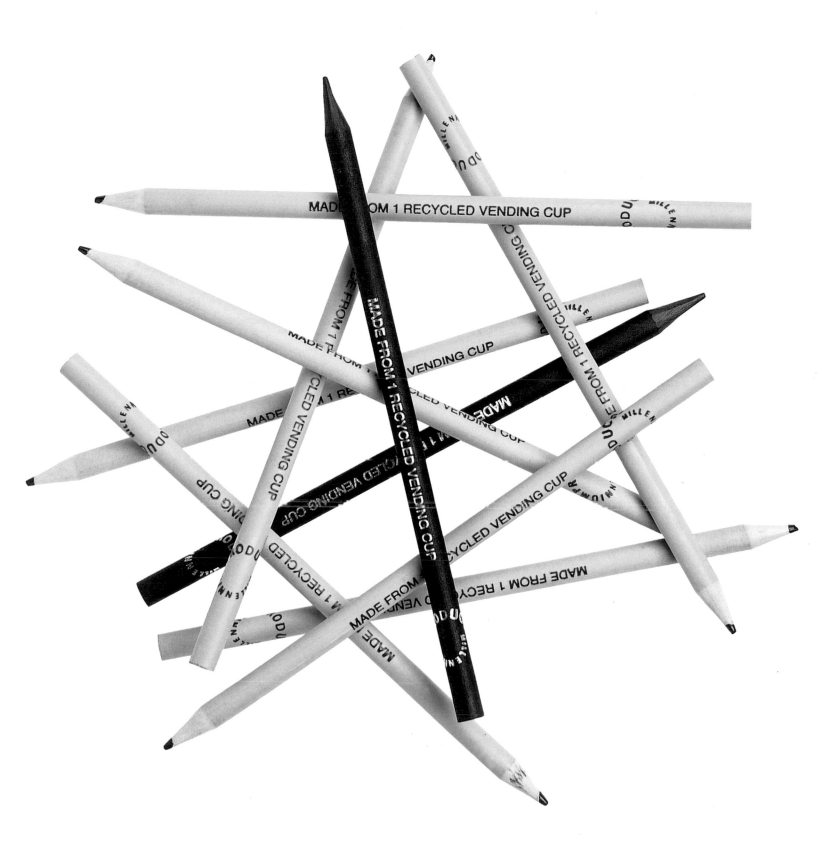

"I cross the office to photocopy an invoice."

Evolve paper

Evolve is one of the leading environmental performing papers in the world for a number of reasons:

It's made from 100 per cent recycled fibre (post-consumer waste).

The raw material is collected within the local region, and many of its users are also within the region, making this product fairly closed-loop and limiting transportation impacts.

When the collected paper is made into pulp, the inks present are extracted out. This 'de-inked sludge' has sufficient qualities for it to be used as a soil conditioner, and it is applied to local farmland.

The mill has a Combined Heat and Power plant (CHP), which allows simultaneous generation of electricity and steam at a claimed world-beating 88 per cent energy efficiency.

Much of the process water is recycled internally, and the eventual effluent is treated in a state-of-the-art waste water treatment facility.

Compared with virgin paper, there is a higher proportion of fossil energy used, as many of the large integrated mills get much of their energy from burning waste wood biomass. However, there is less energy in total used with recycling, as trees do not need to be crushed down.

Recycled raw materials; compostable waste

Less solar power during manufacture

No forest impacts

Improvement in overall energy efficiency

(Baseline: Virgin paper)

"The photocopier is sleeping to conserve energy, so I wake it up again."

Xerox DC265

The Xerox DC265 is designed with only 260 parts which helps it be 98 per cent 're-manufacturable'. This means 80 per cent fewer moving machine parts than before. It also has 50 per cent lower energy consumption than conventional machines.

In fact, all new Xerox digital products have a design goal of 'Zero Landfill'. Zero Landfill is a term which Xerox has trademarked. It means that no part of the Document Centre needs to be thrown away at the end of its life within these machines. This has led to resources conservation (consumption of raw materials worth over £50 million avoided in 1999) and landfill reduction (over 75% less since 1993).

As one of the most significant environmental impacts associated with its business is produced by service engineers driving around the area, Xerox allows technicians to evaluate system performance over a phone line.

There are no hazardous materials associated with inks, fountain solutions, wash solvents, glaze removers, plate developers and finishers, image preserver or colour proofing.

All Xerox digital products are "packaging-free". They are delivered in pallets which are re-used more than 30 times for both delivery and collection of end-of-life equipment.

More cyclic materials use from re-manufacturing

No solar power used in use or during manufacture

Less waste and fewer manufacturing impacts

Less overall materials use

(Baseline: 1990 copier)

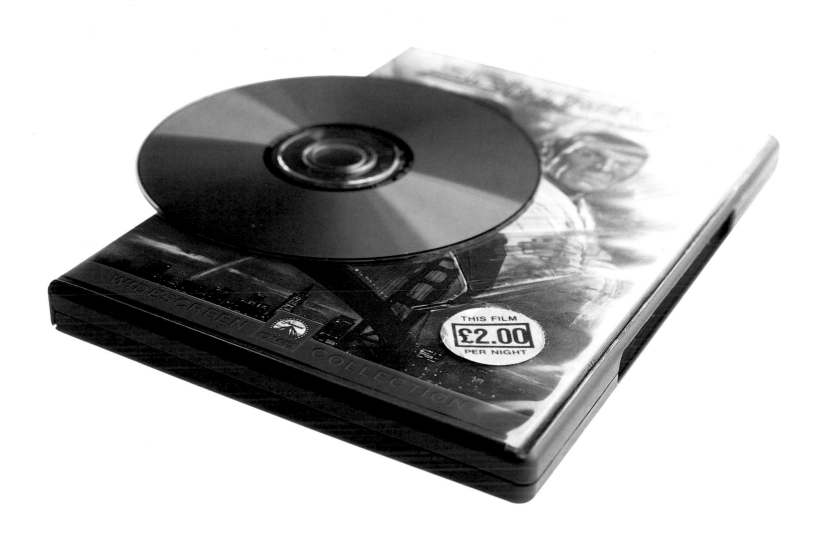

"I nip out to the video shop to rent a DVD. Renting gives much more utility per unit of material than buying."

Rental DVD

Renting and libraries are excellent ways to extend product utility, as hundreds of people see a film with the only materials required being a small piece of aluminium-coated polycarbonate, and some energy in the form of transport to collect it from the rental shop and a tiny amount of electricity to power the TV for a couple of hours.

This particular DVD also brought a powerful ecological message to millions of people, far more than most conventional environmental campaigns can hope to achieve.

The crew of the Starship Enterprise go to an Earth of the future, which is being attacked by a strange alien probe. Spock, analysing the probe's transmissions, determines that they match the songs of humpback whales, an extinct species of ocean-dwelling life. The whales are in fact advanced forms of alien life, and for Earth to survive, the crew of the former Enterprise must travel back in time to 20th-century Earth, capture one of the last humpback whales, confine it in their stolen Klingon spaceship, then return to the future.

CD recycling still in infancy

No solar power used in use or during manufacture

Less pollution per hour of film viewing

Huge improvement in utility and hence materials efficiency

(Baseline: Purchased video)

"Back at the office, it's time for me to recycle some of that tea and coffee."

Waterless urinal

Most water-using urinals flush four times an hour, using up to 250,000 litres (65,000 US gallons) a year. If the flushing system is faulty, they can use a lot more. If you have a sensing device you can save 70 per cent or more – although this will still be the biggest usage of water in an office building.

We have a waterless urinal system, which saves masses of water – and doesn't smell! Similar systems are in use at the UK Environment Agency's own offices and the offices for tabloid newspaper *The Sun* and many other sites.

The Sealtrap waterless urinal system consists of three main components: a polypropylene Sealtrap cartridge; the Airseal sealant liquid and a reinforced fibreglass urinal body.

Urine, which is 96 per cent water, flows down the surface just like water and falls into the trap, where it drops through the sealant and goes down the drain. The system requires 250ml of sealant liquid per year to operate.

Another approach is that of 'Whiff Away', a system which instead of a trap uses a replaceable paper disk with a compound that reacts with the smell-causing molecule in urine. This mops up any odours and eliminates them. The retrofitted units are extremely cheap to convert, and disks are the only consumables.

No difference

No solar power used in use or during manufacture

Some oil is lost down the sewer

Water reduced to a bucket a week

(Baseline: Water flush urinal)

"At my meeting I feel inspired to contribute a few ideas, which I add to the flipchart. Instead of marker pens, we use crayons, which are cheaper."

Prang soybean crayons

Crayons are intuitively better for the environment than flipchart pens as they have no hard plastic to dispose of, and no volatile solvents.

However, this can be further improved by avoiding paraffin wax and going soy-based. Two students at Purdue University came up with the idea while competing in a 'New Uses for Soybeans' competition funded by the Indiana Soybean Development Council. After two years of development this patented idea hit the market. The Purdue researchers found the formula to be comparable in colour transfer and breaking-point strength to leading brand crayons

It's the first and only crayon made from a renewable resource as they are 85 per cent soybean oil. One acre of soybeans can produce 82,368 crayons a year.

The pigments are certified non toxic by The Art and Creative Materials Institute, Inc., but most paraffin crayons are labelled as being non toxic as well. It's a very broad term and I'm not sure what it really means. However, kids often eat crayons, and I'd rather have them eat soy than paraffin.

On November 19, 1997, astronaut Takao Doi from the Japanese Space Agency brought Prang Fun Pro crayons on the Space Shuttle Columbia, making it the first crayon in space.

Grown materials; compostable; recyclable

Solar manufacturing from grown raw materials

Fewer toxic releases in raw materials manufacture

No change in efficiency

(Baseline: Ordinary crayons)

Emeco Hudson chair

Around the meeting room table we have these lovely new Emeco Hudson chairs designed by Philippe Starck.

They are made of pure aluminium, 85 per cent of which is from recycled sources.

They are incredibly strong. Emeco have manufactured similar chairs since the 1930s, including some supplied to the US Navy. When the ships were broken up, the chairs were still good, so they were sold to a restaurant. When the restaurant shut down, the chairs were still fine, so they were sold to a hospital, and so on and so on... This long life gives Emeco chairs a very high efficiency score as the utility derived from the materials is so good.

There are some small polycarbonate glides on the foot of each chair, but essentially the chairs are entirely recyclable.

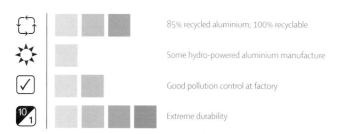

85% recycled aluminium; 100% recyclable

Some hydro-powered aluminium manufacture

Good pollution control at factory

Extreme durability

(Baseline: Standard chair)

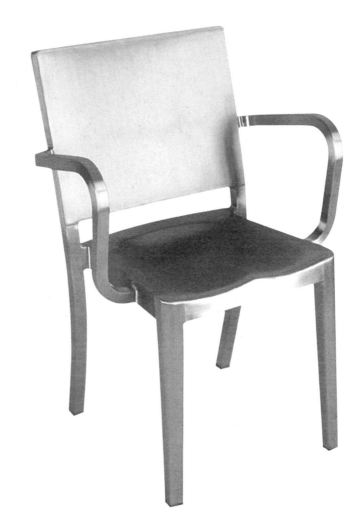

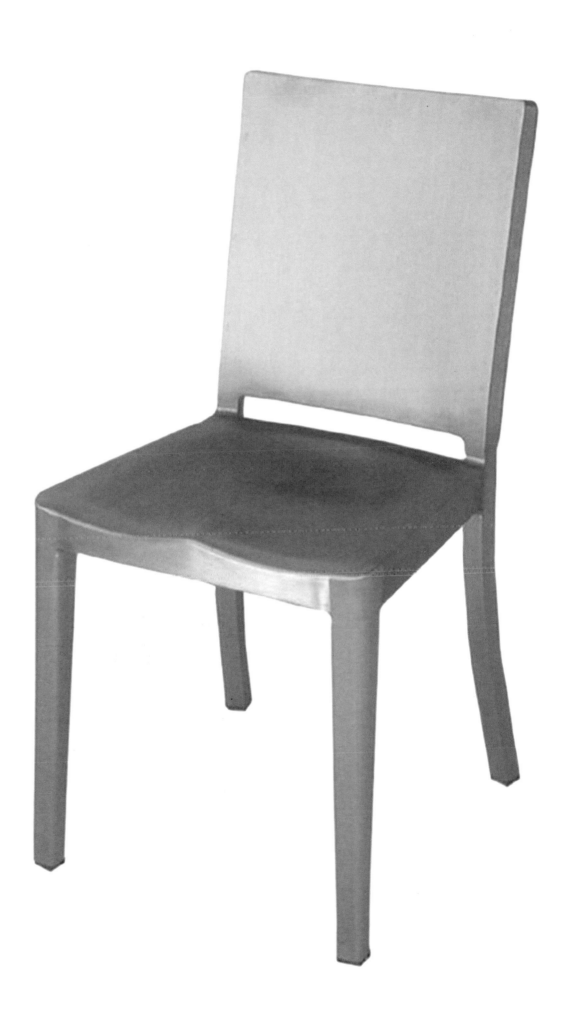

"After a while, my colleague goes home on her ES-X2 electric scooter. She has had it plugged in to recharge during the day."

Electric scooter

The ES-X2 is built by Tokyo R&D, a Japanese firm that was founded in 1981 to develop specialist transport products, especially electric vehicles, including racing cars and scooters. It is based on an earlier model, the ES600, which was not quite so stylish, but a good success as it won the G-Mark design award and did a 2000-mile demonstration trip around Japan in 1997.

The ES-X2 is more stylish, and really shows how design and environmental performance can go hand in hand.

Often people think that electric vehicles are merely moving pollution elsewhere – while there are no emissions out of an exhaust pipe, there is still pollution caused by the power station that makes the electricity. However, in most cases the overall efficiency is higher, so the emissions per mile are less than a combustion engine. And in our case, we are generating electricity from the solar panels on the roof of our office, so Yolanda's scooter really is pollution free.

The ES-X2 can go at 60km/h and has a range of 40km, about the same as a petrol scooter, and more than enough for Yolanda's daily commute. It is powered by the PUES21 motor, which turns at up to 9,000rpm, and has a 72V Nickel Metal-hydride battery. The ES-X2 is on the verge of production, and this image is of an advanced prototype.

Same degree of recyclability as any scooter

No solar power used in use or during manufacture

An overall reduction in lifetime toxic releases

Small improvement in overall energy efficiency

(Baseline: Lambretta)

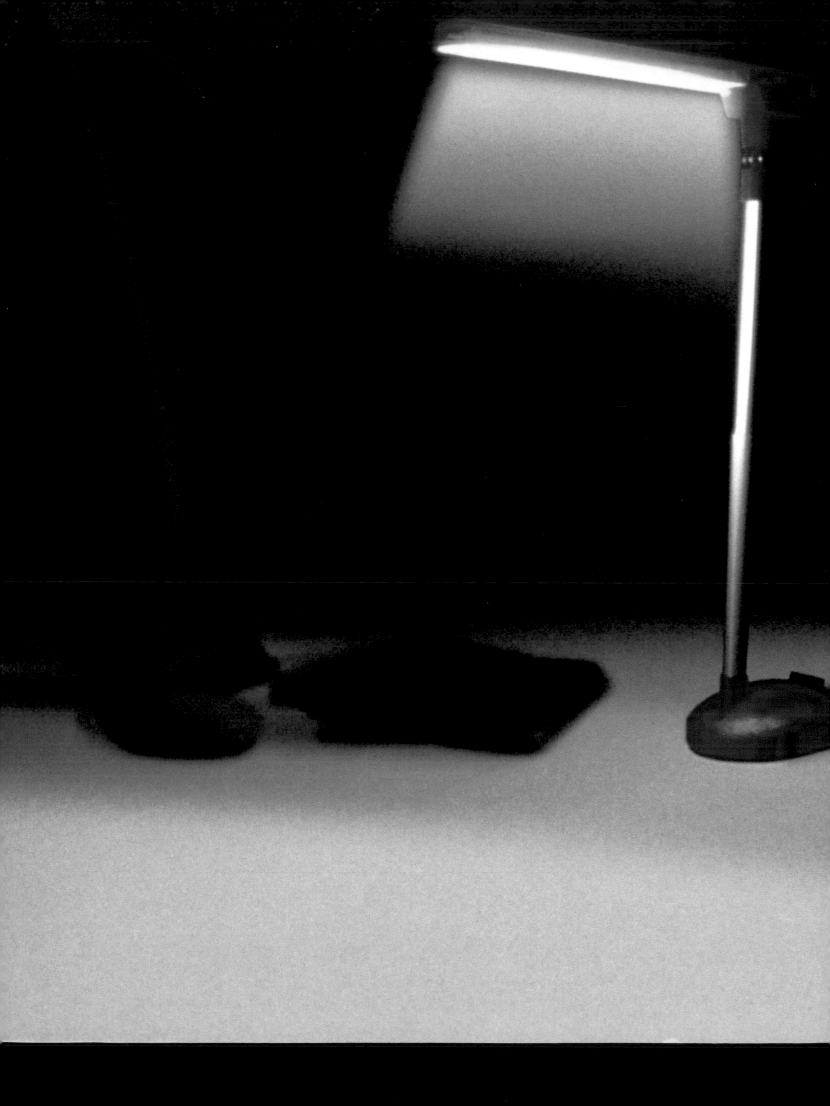

"It's getting quite dark now, so I switch on my e.light."

e.light

The e.light was designed in 1999 by Ernesto Gismondi, who founded the famous Italian lighting firm Artemide, with the aim of designing lights which would reflect a perfect synthesis of form, function, innovation and efficiency.

All the components are designed to be disassembled, and can be recycled.

Compared with normal fluorescent lamps, the e.light contains 93 per cent less mercury.

It's also very durable, as each e.light bulb lasts 20,000 hours or 2–3 times longer than average. This means that fewer bulbs need to be made, and also means that there is even less mercury pollution per hour of light provided, which is the only meaningful measure.

Having 'task lighting', as it is known, is much more energy efficient than lighting the whole office floor – and this particular lamp is even more efficient.

Because the e.light uses only so little power (only 3W, or 94 per cent less than a desk lamp in 1990 would have done), it is cool to the touch, so there is no risk of burning for children or if you have it very close to you on your desk. This coolness also eliminates the need for reflective and heat-resistant materials.

The Microlight Technology also gives out constant, pure colours in the entire light spectrum, through high colour rendering, making it easy on the eyes, and avoiding harmful emissions, such as thermal radiation or ultraviolet rays.

Recyclable

No solar power used in use or during manufacture

Over 90% reduction in toxics

Over 90% improvement in energy efficiency

(Baseline: Anglepoise)

"I grab my Scotty phone charger as tomorrow I'll be working on a field survey, and I need extended talk time."

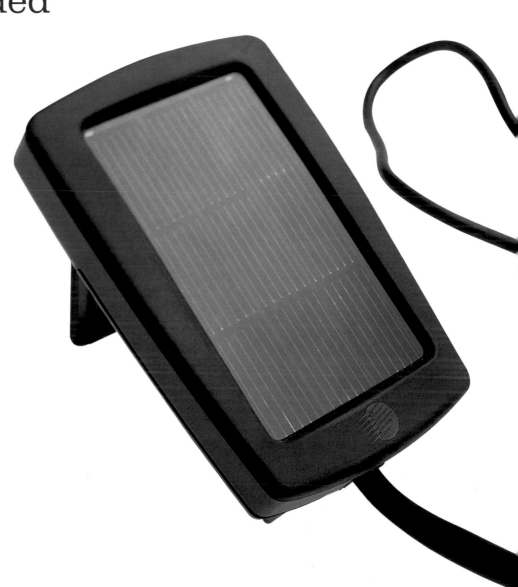

Scotty solar mobile phone charger

This power unit has been recharging on the windowsill all day, and tomorrow I will just be able to clip it on my belt and it give a boost to my mobile phone. One hour's sunshine provides approximately three hours of stand-by operation.

Two internal high-capacity Nickel Metal Hydride batteries act as intermediate storage for charging the phone.

It's only 100 x 60 x 20mm and 125g, so I don't even notice when I'm wearing it.

The solar cells are of the latest generation and highly efficient, producing 400mW.

An LED display tells me of the charging status, and I can use Nickel Metal Hydride, Nickel Cadmium or even ordinary Alkaline batteries in it. It's a really well-made little product.

I also use it to charge my PDA and even my Walkman.

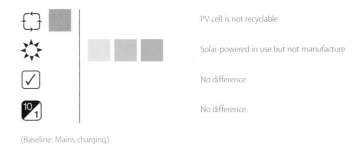

⟳			PV cell is not recyclable
☼			Solar-powered in use but not manufacture
✓			No difference
10/1			No difference

(Baseline: Mains charging)

Lupo

Produced in 1999, the VW Lupo is a real breakthrough in terms of fuel efficiency – it gets 96mpg, which is just three litres of fuel per 100km. The Lupo emits 20 per cent less CO_2 per kilometre than hybrid cars like the Toyota Prius, 40 per cent less than the similarly-sized Ford Ka, and is almost a factor four improvement over a Porsche 911 (although that's hardly a fair comparison).

Our Lupo is even more special, as we run it on biodiesel – fuel made from vegetable oils such as rapeseed. This is a solar resource that burns very cleanly and is starting to become much more available, especially in European countries like Germany, where there are over 500 service stations that have biodiesel pumps in the forecourt.

The Lupo's designers achieved its excellent fuel efficiency by several routes:

The body is made from lightweight aluminium, and the rear door was made 30 per cent lighter by using a magnesium alloy similar to that used to make Formula One racing cars.

The tyres have a reduced rolling resistance.

The body of the car is streamlined for minimum drag.

The transmission is a Tiptronic system, where the electronically controlled automatic gears choose the most optimal settings for maximum performance and minimum fuel use. It's the same technology that's used in some Porsche sports cars.

The engine actually switches off if it is not required, such as at traffic lights, and is able to restart almost instantaneously.

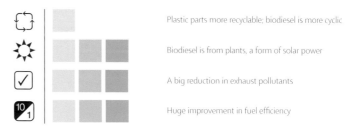

Plastic parts more recyclable; biodiesel is more cyclic

Biodiesel is from plants, a form of solar power

A big reduction in exhaust pollutants

Huge improvement in fuel efficiency

(Baseline: 1990 VW Polo, petroleum fueled)

"Soon after, it's time for me to go home, so I get in the office pool car, a VW Lupo, and head for home."

"When I get home, I'm pretty tired, so I go to the fridge and grab a bottle of organic beer."

Vestfrost fridge

The fridge is a BSKF 375 made by the Danish firm Vestfrost, the first company to be awarded the EU Ecolabel for fridges. The fridge also looks great – it was designed by the artist David Lewis, and has the most commonly-used section, the fridge, at arm height, with the freezer at the bottom, making it very ergonomic to use.

It is very quiet, less than 42 dB (A), which is quieter than a whisper.

It is very cheap to run; it uses half the energy that fridges used a few years ago.

It contains safe refrigerants. In 1991 a professor from South Bank University in London suggested using a simple mixture of propane and butane instead of harmful CFCs and HFCs. People literally laughed at him and said it was unfeasible and even dangerous, as butane can be explosive. He pointed out that the quantities involved were about the same as those in a cigarette lighter, hardly a major safety threat. The idea, known as 'greenfreeze', rapidly took off when it was endorsed by Greenpeace and the first fridges were built by a small German manufacturer DKK Scharfenstein.

Vestfrost introduced its first greenfreeze model in 1993 and the following year found they had a production increase of 39 per cent to 725,000 units over the previous financial year. Now all manufacturers use hydrocarbon refrigerants, finding that they are efficient, have no ozone depletion potential and very low global-warming potential.

	Plastic parts more recyclable
	No solar power used in use or during manufacture
	An overall reduction in lifetime toxic releases; no CFC or HFC
	Good improvement in energy efficiency

(Baseline: 1990 fridge)

"I chuck a load of washing in the machine so I'll have something to wear tomorrow."

Washing machine

The Zanussi IZ washing machine is designed to optimise the use of energy, water and detergent. These three factors are by far the most significant impacts across the whole lifecycle of a washing machine, which is basically a small chemical plant in your kitchen.

Electronic technology takes total control of the wash with a programme to suit every type of fabric and wash load using the minimum amount of water and energy. A time manager function includes a delayed start and a speedwash function.

Traditionally clothes are tumbled after the spin cycle to the base of the drum and showered with the rinse water. The IZ's Total Exchange rinsing system rotates the drum at 80rpm, distributing the laundry around the drum. This allows the rinse water to flow through the fabric, removing the detergent more efficiently.

The Detergent Recovery System means that all of the detergent put into the machine is used and is not wasted – economically and environmentally sound.

The IZ has an 'A' wash performance and an 'A' energy rating. Energy use is 0.21 kWh/kg, which is very good, but matched by the leading Hoover, Nordland and AEG machines. Water use is 9.3 l/kg, which is very good and only beaten by its stablemate the AEG OKO_Lavamat 86720 which uses 7.8 l/kg.

In terms of style and ergonomics, the porthole is 300mm in diameter and opens to 180°, which makes loading and unloading easier, and the inclined drum makes more efficient use of water.

Because 80 per cent of the energy is used to heat the water, I tend to wash darks at room temperature, and so make even more savings.

Better recyclability

No solar power used in use or during manufacture

Fewer toxic materials in manufacture; less detergent in effluent

Big reduction in energy, water and detergent use; more reliable

(Baseline: 1990 washing machine)

Unit[e]

In the US and UK there has been deregulation of the consumer electricity market. This means that I can buy my electricity from whomever I like, instead of relying on the old monopoly supplier. The electricity still flows across the same grid network from the power stations to my house, and you can't trace where the electrons come from, but you are effectively supporting your supplier when you buy from them.

I buy from Unit[e] Europe AG, which in the UK supply only electricity generated by wind power from Cornwall and hydroelectric power from Wales.

Production costs for wind-powered electricity have reduced significantly over the past decade and have now reached a level where the premium over 'brown prices' is acceptable to many customers. I pay a small premium over the standard price which will support Unit[e] in sourcing renewable energy from both existing and new power plants.

Unit[e] establishes and operates small and medium-sized hydroelectric plants, wind farms and other systems producing electricity from renewable sources, and also purchases existing plants and optimises their productivity.

Each year I save around two tonnes of the global-warming gas CO_2 from entering the atmosphere by purchasing renewable electricity from Unit[e].

Unit[e] is independently audited by Future Energy to verify that the content of its product is made up of renewable electricity.

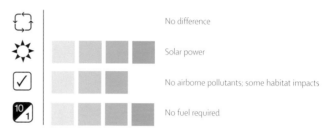

No difference

Solar power

No airborne pollutants; some habitat impacts

No fuel required

(Baseline: Standard electricity supply)

"The power in my house will come from a windmill we are building, but in the meantime I purchase renewable electricity from Unit[e]."

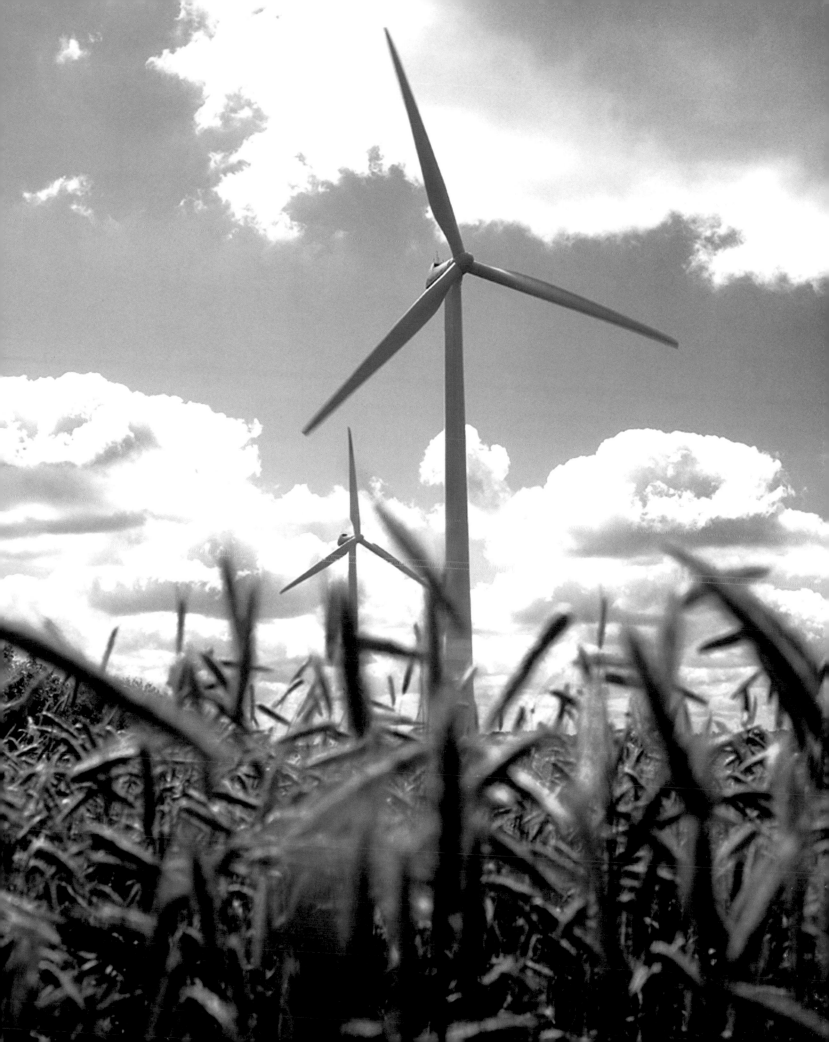

"To go out to the garden to dig up something for supper, I pull on my recycled Wellington boots."

Dunlop recycled boots

PVC has its problems, especially during original manufacture, when workers can be exposed to the carcinogen Vinyl Chloride Monomer. If burnt, it produces highly toxic fumes. However, in a closed-loop recycling system, it has excellent characteristics and can be used again and again. It is also strong, fully waterproof, and has good resistance to oils, fats and acids.

The material in my boots was originally collected by Dorset County Council in the form of worn-out boots. They were then sent to the main Dunlop factory in Liverpool.

The old boots were washed and shredded and then granulated into 3mm particles known as 'jazz'. Nylon fluff from the original linings is removed at this stage. The material can then be injected into the moulds to form new Wellington boots.

There are only two colours that can be achieved, black and grey, hence the grey sole and black uppers. This is standard colouring for wellies, so this is not a design constraint.

Some of Dunlop's boots have a part-recycled component; others, like the Black Dee, are made of 100 per cent recycled material. These boots have the same purchase price as their conventional counterparts.

Recycled and recyclable; closed loop

No solar power used in use or during manufacture

No VC monomer releases

Same efficiency and durability

(Baseline: Ordinary Wellington boots)

Nightstar torch

The Nightstar torch is really designed as a no-compromise survivalist torch, but it has some interesting environmental features in the form of no batteries or rechargeable cells, highly efficient LED bulb and excellent durability.

It is powered by moving a high-field-strength rare earth magnet through a coil. Thirty seconds of shaking fully charges the capacitor providing five minutes of reading level illumination. The energy is stored in a capacitor which then powers the white-light LED. The light is effectively collected by a precision acrylic lens.

In total darkness Nightstar is claimed to illuminate a six-foot diameter area from a distance of 30 feet, and is visible from over a mile. In practice, the light produced is quite faint, but that's all you need when it's really dark.

The polycarbonate/ABS housing makes it lightweight, chemically resistant to many solvents and nearly indestructible.

"It's really dark out in the garden, so I give my torch a few shakes to illuminate my potato plants."

Nightstar currently uses a 1 Farad, 5.5V capacitor which gives five minutes of useful light after 30 seconds of shaking. Neodymium magnets are mounted at both ends of the flashlight and are oriented to repel the charging magnet. The magnetic repulsion recoil system smoothly decelerates and accelerates the charging magnet back through the coil without loss in mechanical energy. Consequently, the loss of energy due to friction is extremely small and is only the result of the cylindrically shaped nickel-plated charging magnet sliding through a polished tube. Kinetic energy is therefore efficiently coupled into electrical energy with almost no degradation to the system.

Same degree of recyclability as any torch

Muscles are solar power

No battery wastes

No battery manufacture; high efficiency bulb; greater reliability

(Baseline: Battery torch, filament bulb)

"I dig up a half dozen King Edwards and some carrots for supper."

Garden vegetables

Home-grown vegetables are fantastic sustainable products:

No pesticides or artificial fertilisers. The manufacture of such chemicals causes pollution, and pesticides can be washed away by the rain to cause problems elsewhere.

They make fully cyclic use of composted kitchen waste. Instead of using synthetic fertilisers, I use a compost made from my kitchen waste. This is far better than sending my organic wastes to landfill.

My home-grown vegetables also have no transport impacts. Just consider the amount of diesel fuel used by the average supermarket vegetable which has travelled over 100 miles. And that's without considering all the energy used by refrigeration units.

More cyclic as peelings and human waste go back into garden

Passively solar-heated compost

No pesticides or synthetic fertilisers

No food miles; no tractor pollution; no packaging

(Baseline: Supermarket vegetables)

Martin SWD
Wood guitar

The Martin SWD Certified Wood Dreadnought acoustic guitar was the company's first certified wood model. More than 70 per cent of the wood used in its construction is harvested from forests independently certified by the Rainforest Alliance's 'SmartWood' programme and Scientific Certification Systems, both of which operate in accordance with the rules of the industry's governing body, The Forest Stewardship Council.

Certified cherry is utilised for the back, sides, neck, and interior blocks of the SWD model. Cherry has a warm, natural, visual beauty, especially when combined with Martin's traditional dark staining. As a tonewood, cherry yields a strong, projective, and balanced sound, with many of the best attributes of more traditional guitar woods like rosewood, koa and mahogany. Certified hard maple is utilised for the bridge support plate on the underside of the top.

Quartersawn Sitka spruce is used for both the soundboard and the internal bracing of the SWD model. The logs from which this wood comes were destined to become pulpwood, but were reclaimed instead specifically for the SWD guitar project. This spruce is not yet certified.

An interior label indicates that a portion of the proceeds from the sale of the guitar will be donated to the Rainforest Foundation International. The RFI was founded to support indigenous peoples and traditional populations of the rainforest in their efforts to protect both their environment and rights.

As cyclic as any guitar

No more solar power used in use or during manufacture

Less habitat disruption and no threat to rare wood species

Same materials and energy efficiency

(Baseline: Traditional guitar)

Guitar strings

These guitar strings are by D'Addario, who developed the colour codings systems to reduce the amount of packaging required. Normally a set of strings comes in a packet with six individual packets within it, to distinguish the different string thicknesses. D'Addario dispensed with the inner packets and simply colour-coded each string. This means each set of strings uses 75 per cent less packaging. The outer packet is recycled card, printed with soy-based inks, giving a further environmental benefit.

"After dinner, I take some time to practise my guitar."

"I switch on a light in the sitting room."

OR'ION salt lamp

The shade on my bedside lamp is made from polished rock salt crystal, mined a mile below the ground in Poland. The pleasing amber glow results from the incorporation of iron, potassium, magnesium and other minerals.

The lamp actually cleanses the air by absorbing and evaporating humidity. This process also releases negative ions, which neutralises positively charged particles of air pollution. Ideal for sleeping next to.

	Can be crushed and dissolved at end of life
	Similar solarity
	Less pollution overall
	Much less manufacturing energy used

(Baseline: Metal-shaded lamp)

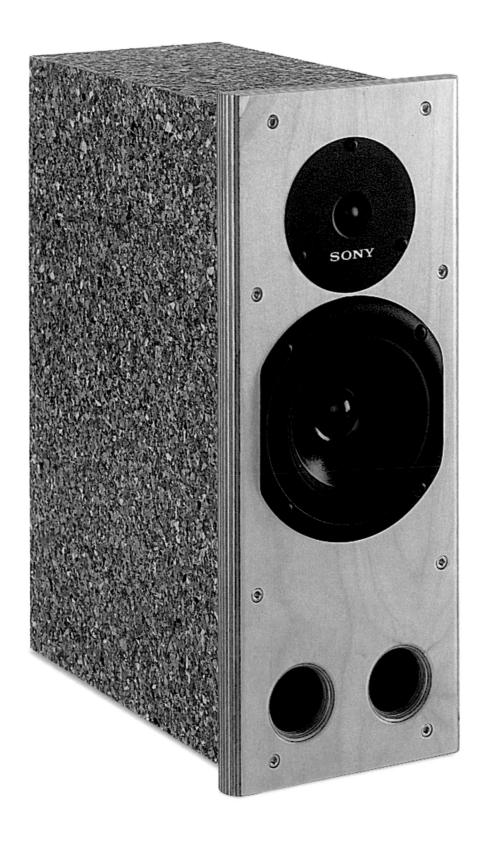

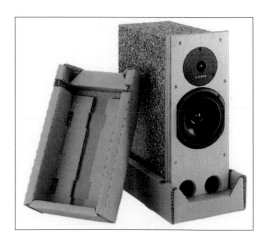

"As I stroll into the living room, I fancy some music, so I fire up the computer which has downloaded some MP3 music files."

Sony recycled speakers

I don't have a hi-fi as my computer can perform that function, saving another chunk of electronics waste. I have hooked the computer up to my new SS-BG30 Tectan loudspeakers, which are made from recycled Tetrapak cartons and similar materials. Manufactured by Sony, these loudspeakers are good because:

They are made from a recycled material.

No adhesives are used, which means fewer emissions in manufacture and also ensures recyclability.

When they are delivered, they arrive in cleverly-folded cardboard boxes, with no need for polystyrene foam.

They got a good score in the German magazine *Audio*, and they sound great, but I also got them because they look nice.

Recycled material used

No solar power used in use or during manufacture

No need for glues, paint or lacquer

Tectan is about the same weight as wood

(Baseline: Standard wood cabinet hi-fi speakers)

SoftAir sofa

SoftAir is a Swedish manufacturer that makes inflatable furniture for IKEA and also for Muji in Japan. This sofa is filled with air and is a modern update on the old 1970s' PVC inflatable furniture, but it is more comfortable and doesn't leak. Compared with a traditional upholstered sofa, the SoftAir has many environmental benefits:

Its manufacture uses 83 per cent fewer resources in terms of materials and energy.

The air cells are made of 100 per cent recyclable polyolefin plastic.

This soft plastic is extremely pure. In the event of fire it produces no toxic fumes. It burns in a slow and subdued fashion and generates little smoke.

It only takes up about ten per cent of the space during warehousing and transportation.

The air cells do not have welded seams, but are manufactured in one single piece with an airtight sealing cap to eliminate the risk of any air leaking out. There is no need to top up the air for at least three years.

Recycling is often a complex and costly process. For SoftAir, however, this cost is negligible. Disassembly for recycling is almost instantaneous.

They have easily removable fabric covers, which are themselves recyclable. This also means that the covers can be changed to keep up with new fashions, so extending the lifetime of the product. It also means that they are washable, helping people with allergies to pets, for example.

Not made from recycled or grown material, but 100% recyclable

Muscle-power used if you use your lungs instead of a hair dryer to blow it up

Fewer emissions in manufacture as fewer materials are required

Fewer materials needed

(Baseline: Classic armchair)

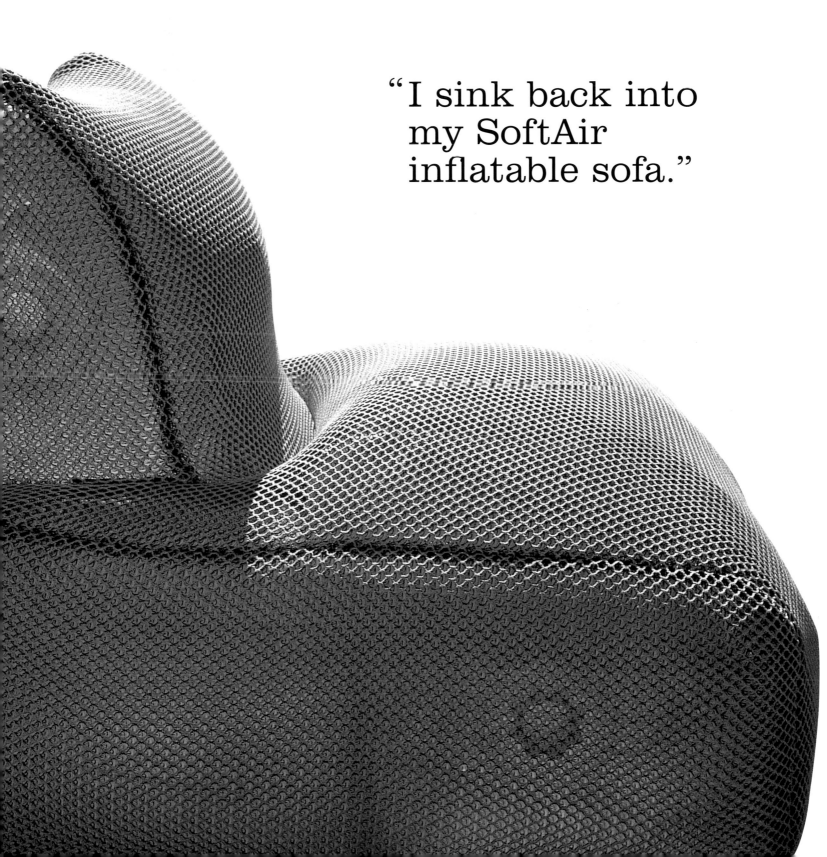

"I sink back into my SoftAir inflatable sofa."

Radius original toothbrush

My toothbrush is made from cellulose, a material derived from wood pulp which in this case comes from a sustainable yield plantation in North Carolina. Five kilograms of wood are required to make 40 toothbrushes. The same amount of wood is needed to make just one copy of the Sunday edition of the *New York Times*.

The packaging went through three variations:

First, they tried a cardboard box. Many customers opened the opaque box to see and feel the toothbrush. To prevent this they made a special brush to use as a tester, which lasted about four weeks and had to be thrown away and replaced. The tester has to be mounted on a temporary plastic display to show the toothbrush. The net result was unacceptable levels of waste.

The next approach was to use a transparent vinyl plastic box. Finally the toothbrush was viewable and did not need temporary displays. However, each customer bought the toothbrush and then threw the box away.

Finally, they developed the injection-moulded travel case. This transformed the packaging into a useful item, meaning that customers can use their toothbrush on a trip, in the office or keep it in the box. The box is strong and does not need protective outer cartons. The box lasts as long as the brush and by then it is time for it to be retired and placed in the same recycling bin as soda bottles.

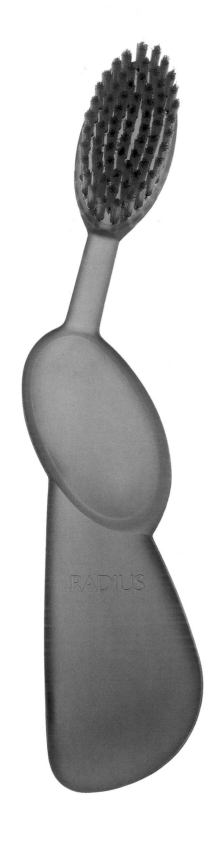

Cellulose-grown raw materials; re-usable and recyclable packaging

Solar-grown raw materials

Less polluting releases in manufacture

Four times longer life

(Baseline: Standard toothbrush)

Urtekram toothpaste

Most toothpaste is made of a complex mix of synthetic chemicals. Danish company Urtekram set out to change that. They make their toothpaste from chalk, vegetable glycerine, water, agar, fennel oil, myrrh, propolis, and "nothing else".

All their ingredients are vegan and organic.

The Urtekram factory has natural lighting, and a windmill and hay-burning power station, so it is self-sufficient.

Their 35 workers have flexible schedules, and if they commute by bike, they have a mileage allowance added to their pay cheque.

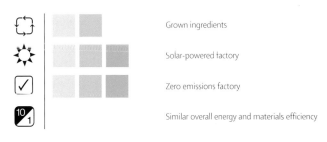

Grown ingredients

Solar-powered factory

Zero emissions factory

Similar overall energy and materials efficiency

(Baseline: Standard toothpaste)

"I start to brush my teeth before bedtime."

"And so to bed."

Natura bed

My bed is made of two rolling, flexible layers of untreated ash wood slats which provide flexible, horizontal support. The slats conform to the contours of my body, as I've adjusted the back and head rest positions to suit me exactly.

My mattress, pillow and duvet are filled with organically grown wool (enhanced by careful clipping practices and a biological washing process), and sealed in 100 per cent organic cotton grown without the use of chemicals and pesticides.

The wool is breathable and acts as a natural insulator yet is cool in the summer. Wool's dry environment and naturally springy coils wick moisture away from body, preventing the build-up of mould, mildew and dust mites. This helps my allergies.

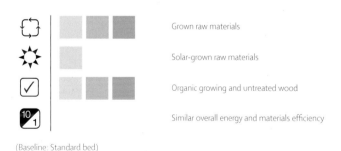

Grown raw materials

Solar-grown raw materials

Organic growing and untreated wood

Similar overall energy and materials efficiency

(Baseline: Standard bed)

"Another sustainable day has ended."

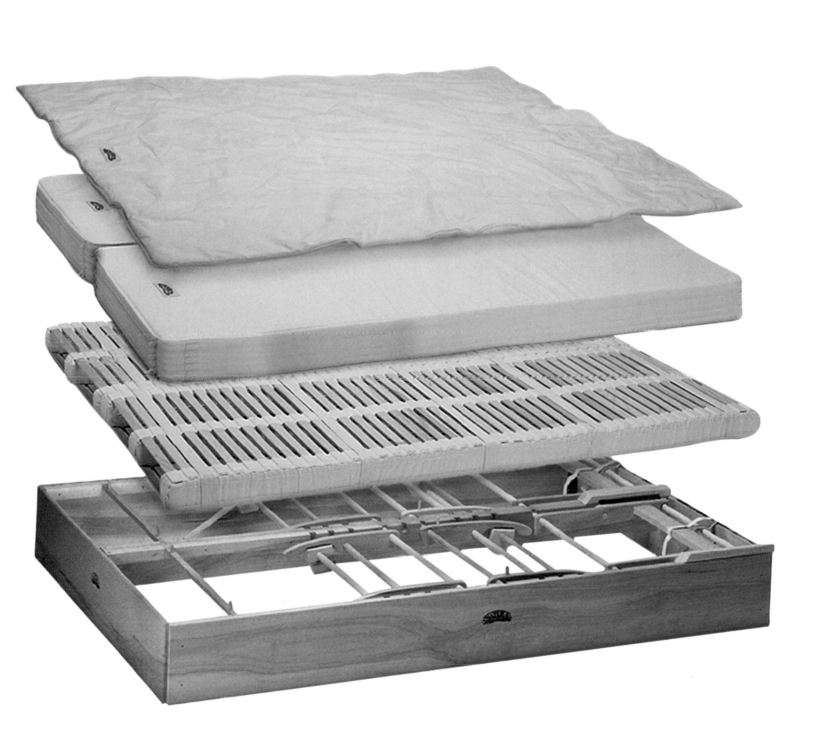

Make your
next product
totally
beautiful.

t
y

hank
ou

The world will

for it.

HOW TO ASSESS THE BEAUTY OF PRODUCTS

How to Assess the Beauty of Products

The goal of sustainable design is simple – to make all products 100 per cent cyclic, solar and safe.

If you are a manufacturer, this means looking at each one of your product lines and making a long-term plan to bring them all up to speed. If you are a service organisation, it means looking at all the things you buy, and making a plan to change their specification and seek out products that are nearer to being 100 per cent environmentally sustainable.

You've already seen from the product examples above that we impact on the environment in many different ways. Figuring it all out is very complex. There are hundreds of parameters to consider. To really do it properly, you need to do a lifecycle assessment study that could take many months and cost tens of thousands of pounds.

Prioritise

While 100 per cent is the goal, it makes sense to prioritise one's improvement efforts, and the best way to do this is to see which of a firm's activities or materials usage takes up the most Ecological Space. Ecological Space is the amount of air, land, water and energy taken up by the entire lifecycle of a product. It is broadly proportional to the mass of materials used, and as some materials clearly have more of an environmental impact than others (a tonne of mercury requires more of your attention than a tonne of wood, for example), a scoring system is helpful.

In general, the mass of material used is proportional to the environmental impacts arising during its manufacture, use and disposal. For example:

- during extraction of raw materials;
- energy used in processing and manufacturing;
- waste arising during manufacture;
- fuel used in distribution;
- packaging needed.

I have given each type of material an UglyPoints score that shows its 'Hidden Ugliness' impact per tonne. The UglyPoints score is very crude but it is simple to use and remember, and it is based on a composite index I made which was partly derived from highly credible sources such as the Dutch EcoPoints system, the Swiss BUWAL, the German MIPS and the Swedish EPS materials scoring approaches. The resulting system presented here, however, is entirely my own responsibility, and as I said, is only intended to be a rough guide. For one thing, a materials type made in two different factories will have two different scores. But broadly speaking, they will tend to remain within a point or two of each other. The purpose of UglyPoints is to help designers quickly spot where the main problems are.

My system gives either 1, 5, 15, or 50 UglyPoints per tonne for the various materials types:

UglyPoints per kilogram

Low = 1
Bioplastic, Brick, Cardboard, Ceramics, Concrete, Stone, Wood

Medium = 5
Carpet, Food, Glass, Leather, most Plastics, Paper, Rubber, Steel, Textiles

High = 15
Aluminium, Electronics, Light bulbs, Paint, Polycarbonate, Polystyrene, Stainless steel

Very High = 50
Batteries, Brass, Cadmium, Chromed steel, Chromium, Copper, Gold, Lead, Nickel, Zinc

To calculate the relative environmental importance of the different materials flows in your process, simply multiply the mass by 1, 5, 15, or 50 as appropriate. From these figures you can rank the materials flows and then prioritise design efforts.

Product scoring

The human brain is excellent at spotting differences, and what we are really looking for here is the difference the innovation makes. So you simply choose a baseline and then decide for each requirement whether the product is a bit better than before, scoring out of +/- 4:

+2

or a lot better than before:

+4

or about the same:

0

or worse:

-2

and so on.

Selecting the baseline product is important. Normally the market leading brand in 1990 is the best choice for a baseline, but it could also be your existing product line. The reason for choosing 1990 is that there are many international environmental targets that have been set based on progress from that date, and the efficiency requirement is to improve material and energy efficiency by a factor of ten compared with 1990.

So putting together these relative scores (remember to think across the whole life of the product), we get a score that might look like this:

Score for AEG86720 (Baseline: 1990 Creda)

Recyclability improved

Same solar power during use and manufacture

Reduction in toxics used in paints and energy production

60% improvement in energy and water efficiency

There is some limited interaction between the criteria – for example if efficiency is increased due to lifetime extension, there will probably be an increase in safety as well due to less manufacturing pollution occurring per unit of consumption. The other effect is that for an increase in plastics and metals cyclicity, there is a corresponding increase in safety as manufacturing pollution per tonne decreases (this is usually but not always true for paper products).

Important note about scores for products

I have given many of the products in this book a relative score. This is based on standard information provided by manufacturers and suppliers. In some cases I held a discussion with the product's makers.

Because of this quite minimal amount of data, it is possible that some products may be better for the environment and people than I have implied. It is also possible that some products may be worse.

However, the purpose of my scoring system is to show that surprisingly accurate assessments can be made very quickly and using small amounts of information. Because we are looking at the differences, and not the absolute performance, the scoring is a relatively easy task. It also capitalises on the human brain's terrific ability to spot differences.

My approach is not intended to replace a more thorough lifecycle assessment of a product's performance, as would typically be carried out by a manufacturer or designer wishing to have evidence and information to support multi-million dollar decisions. Such an assessment would involve audits of suppliers, extensive data gathering and detailed impact calculations taking several months.

The scoring system has proven to be very robust and I hope that it is useful for its intended use – as a learning tool for designers and manufacturers who are new to sustainability, and as a 'quick and dirty' assessment tool for people exploring new product possibilities.

80:20 Product planning

By analysing the materials used in a product, and changing those which are used accordingly, any designer can make a significant environmental improvement. Taking it a step further, an environmental sustainability plan for the product can be mapped out.

The first step is data collection, finding out how many tonnes of each type of material flows through the product system. Then comes an assessment process that ranks these materials flows by UglyPoints, showing which ones are the most important.

From this an 80:20 Product Plan can be drawn up. This takes the top 20 per cent of the materials flow of the product that cause 80 per cent of the impacts, and then makes a plan for them to be 80 per cent sustainable by the year 2020, with a view to being 100 per cent sustainable by 2100.

Getting a picture of a product's environmental impacts is simply a matter of sitting down with a small team and thinking through the materials and items used in a typical year. You can literally draw a picture of materials flows showing the 'ins' and 'outs'.

It is important to include the materials usage of suppliers and contractors. Include everything that you can think of at this stage – if some things turn out to be genuinely insignificant, we can and will exclude them later on, but it is vital to get a complete picture at this stage.

Don't worry too much about the raw materials used by manufacturers – the 'upstream' impacts of products and materials, such as the coal and iron ore used to make steel, for example, are already included in the data provided above.

Once the priority materials have been identified, do a thorough cyclic|solar|safe score on the product. Once a product has been assessed, the direction for improvement is usually obvious. The challenge usually requires two approaches: an immediate, 'low-hanging fruit' approach and a more Blue Sky strategic transition plan.

The product team can get thinking both short- and long-term about what product specification would meet the cyclic|solar|safe goals. It could be that a short-term target of 30 per cent or 50 per cent cyclic|solar|safe can be set, depending on the product type

Once the direction is clear, the solutions will present themselves – and so will the barriers! Changing which products are bought or the purchase specifications themselves is a balancing act between price, performance and user perceptions. With care and dedication, these factors can be navigated through, but most of all there needs to be commitment from the top.

The beauty of an 80:20 Product Plan is that it is clear and simple, so that senior executives can understand it and so that it can be communicated clearly and incorporated into the organisation's overall business strategy.

MATERIALS ARE
THE MESSAGE

All designers are interested in materials. Bear in mind that simply changing the materials type does not automatically make a better product. Below is a selection of noteworthy materials, types and trends that you should be aware of.

Avoid

The first step is to make sure your designs avoid the very worst 'black list' compounds, which include: CFCs, Asbestos, Halons, PCBs, Carbon tetrachloride, Lead chromate, Cadmium, and Mercury. This is a very basic starting place. The list of chemicals worth avoiding is getting longer and longer. Volvo have very useful black and grey lists at www.tech.volvo.se/standard/docs/10092.pdf,10091.pdf and 100911.pdf

Leather

Vegetable-tanned leather that avoids the use of chromium is available under the Ecopell brand name in Europe.

In the US, Sustana leather is made from hides of sustainably managed cattle supplied by the Coleman ranch company in Colorado. Coleman cattle are raised humanely from birth without steroids, growth hormones and antibiotics. They are fed on pesticide-free feed and water and allowed to roam on pastureland that is managed on a rotational grazing system to reduce the impacts of overgrazing. Sustana hides are tanned by Cudahy Tanning, a family-owned, specialty leather producer in

Wisconsin. The tanning and finishing standards for Sustana are based on the Dutch Ecolabel for Footwear, which include use of low-toxicity trivalent chromium, minimal release of effluents, low impact, chlorine-free water-based dyes and finishes, biological purifying systems and recycling of protein wastes.

Wool

Small amounts of organic wool are available from New Zealand and Iceland. Many countries still use strong pesticides for sheep dip. Wool can also be used for non-fibre applications, such as Clima Wool, a building insulation product.

Secondary metals

Recycled or 'secondary' metal is in principle an excellent idea. Aluminium, brass and steel are all available as 100 per cent recycled material. However, it is important to note that all aluminium contains recycled metal (about 30 per cent in Europe), so be wary of claims that a metal supply is 'recycled'.

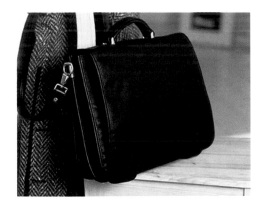

1. Hess Natur briefcase
This Hess Natur briefcase is made from Ecopell vegetable-tanned leather.

2. Clima Wool
Clima Wool serves as a health-friendly building-insulation product.

Cotton

We've already heard about some of the negative impacts of cotton production, such as the high intensity of pesticide use. It's also contentious in its use of child labour in picking. And that's just producing the fibre. Then there's the chemicals used in bleaching, softening, sizing, dyeing and fireproofing.

The only way to go is to use organic cotton. The main body overseeing organic certification of cotton is the International Federation of Organic Agriculture Movements (IFOAM). Organic cotton has become increasingly available, and should be easy to source.

Another approach is to use recycled cotton. Denim has been collected from both consumers in the form of worn-out jeans, and from factory offcuts. The fibre can be re-carded and respun and woven into a new fabric. Alternatively, the shredded denim can be used in its own right. Ford have used shredded denim as sound proofing in some of their European cars.

Bioplastic

Bioplastics are plastics made from plants, usually polymers of starch or polylactic acid (PLA). They are being used for bags, cutlery and plates, pens, clothing, credit cards, food packaging, agricultural films, tea bags, coffee filters, diapers and napkins.

The main brands of the plastic itself are: Biopol; Bionolle; NatureWorks; and Mater-Bi. These plastics are cyclic in their sourcing, with starch coming from plants, particularly in Europe where the 'starch mountains' some years ago prompted the research that led to the development of starch plastics. It is also possible to make PLA from milk residues and even household waste.

Even Barbie may go bioplastic. The company intends to begin the introduction of products produced from organically derived materials as early as 2001. As the viability of these new technologies is confirmed, their use will be expanded into all brand categories and product lines.

3. Foxfibre cotton
Colour-grown cotton like Foxfibre is a strain derived from various wild brown, red and green cotton plants.

4. Jeans pencil
The jeans pencil is made from recycled shredded denim.

Belgian company Ecover have developed a potato-starch product to replace plastic bags. They are ideal for areas where kitchen waste is collected by the local authority and sent to large composting facilities. Instead of having to debag the waste, these bags simply decompose and become part of the resulting compost.

Another major company to use bioplastics is EarthShell, which make a range of packaging including clamshells for burger wrapping. The manufacturing process used to create the EarthShell material is very much like that used for making a waffle or an ice cream cone. The ingredients – limestone, starch, fibre, and water – are mixed together and the resulting 'batter' is placed between two heated mould plates. The water turns to steam, expanding the batter in the mould which forms and sets the product.

The respected laboratory Franklin Associates conducted a study which showed that an EarthShell requires 60 per cent less energy to make than an equivalent polystyrene container.

Wood products

General and unsupported claims that a wood comes 'from a sustainable source' or from 'managed forests' are completely worthless.

The Forest Stewardship Council (FSC) is an independent organisation that monitors forest certification and is the most trustworthy label around at the moment. See page 52 for more details.

Coppiced wood is where thin trunks are harvested over a very short growing cycle, and clever design is needed to utilise this wood as it is too narrow to make planks. The Westminster Lodge at Hooke Park in Dorset makes significant use of thinnings as an economic and viable building material.

Designers may wish to consider the ancient Japanese notion of 'wabi', which is the appreciation of natural forms and flaws. An example can be found in the Tokugawa Palace in Nagoya, where an exquisite tea

5. Ecover plastic bag
Ecover have produced a bioplastic bag made from potato peelings.

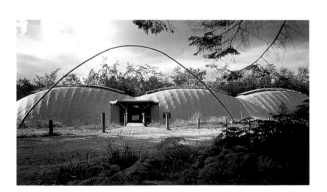

6. Hooke Park
The Westminster Lodge at Hooke Park makes good use of coppiced wood, usually a wasted product.

room interior makes a feature out of a particularly gnarly knot in a supporting beam, rather than excising it as a blemish.

Bamboo is very fast growing and has a higher tensile strength than steel. It has been used for furniture and building materials and countless other uses.

It's the treatment and finishing of wood that causes the most impacts. For indoor uses it's not always necessary to use preservatives or even varnish. A coating of organic linseed oil can suffice.

Wood is such a familiar material, it can be hard to realise how it can be used today. Many things that are made in plastic that have fairly simple shape and low stress requirements can be made with wood instead.

Paper

Which paper is best for the environment is a controversial issue, with many proponents for each of the major types: virgin, recycled, kenaf, cotton, and hemp. In my experience this probably means that there is not a whole lot to choose between them in the big scheme of things. They are all grown materials that can be recycled and are compostable.

This really is a topic area that could fill a whole book, but in summary, my opinion is that recycled paper is often better overall for 'low-art' applications. Carefully-chosen virgin paper made by mills with a demonstrable environmental track record and which are "totally chlorine free" are acceptable for 'high-art' full colour applications.

7. Plyboo
The Plyboo floor for this kitchen is made from bamboo.

8. Highlighter pencil
An example of untreated wood, these highlighter pencils are untreated and unvarnished.

Hemp

Hemp is almost always grown organically, although evidence of organic certification is worth seeking. The material is used in a truly remarkable range of product types, including clothes and accessories, string and rope, paper and paperboard, food, fuel, furniture, bedding and construction materials, cosmetics, art supplies and hemp-based plastic. The oil in hemp seeds has a wealth of industrial uses, and nutritionally, it's a rich source of essential fatty acids. Jute and Sisal also have useful physical properties.

Cardboard

An unexpected application of cardboard is as a building material, replacing more material and energy-intensive products such as concrete or steel. Architect Shigeru Ban has designed about a dozen buildings using cardboard tubes as primary structural supports and walls. A prototype cardboard building for Westborough School in Essex, England, uses 90 per cent recycled materials and is 90 per cent recyclable at end of life.

The biggest challenges in designing with cardboard are overcoming the twin threats from fire and water. Cardboard is surprisingly good in fire, behaving in a similar manner to solid timber, charring on the surface rather than burning quickly. A range of treatments can be added to minimise the surface spread of flame, and reduce risk.

Water is the main challenge, as wet cardboard will lose strength very quickly. At Westborough the wall design incorporates a three-level approach to keep moisture out. A recycled plastic coating-material outer layer, both inside and out, protects an inner load-bearing core. The main panel will be as water-resistant as possible, using techniques researched from the packaging industry. The third level will give the paper in the card itself a small amount of water resistance, through an additive that can be removed if the card is re-pulped. Cardboard is also a fantastic packaging material, with extremely clever folding systems able to replace most polystyrene foam packaging.

9. Kyocera knife
Kyocera have used their expertise in advanced ceramics to make a kitchen knife that is highly durable and never needs sharpening.

Ceramics and Glass

Ceramics generally have much lower embergy than plastics or metals, so advanced ceramic applications such as Kyocera's ceramic knives and engine parts are worth considering. Glass is often made up of 20 per cent or more recycled cullet, and it is also possible to find 100 per cent recycled glass. However, high performance glass will usually be mostly virgin.

Stone and Slate

Stone is obviously heavy, so is a bad idea for mobile or packaging applications. But it is excellent for construction.

Slate such as Welsh Slate is a very low-impact material indeed, and is waterproof and non-combustible (AA fire rating) as well as being unaffected by UV light, normal extremes of temperature, atmospheric pollution, sea air and salt spray, moss and lichen growth, rot or insect attack. It's compatible with all building materials and lasts for more than 100 years.

Batteries

For reference, this is a snapshot summary of battery types:

Bad:
Disposable batteries (alkaline like Duracell) or lithium Nickel Cadmium (NiCad) rechargeable

Acceptable:
Nickel Metal Hydride (NiMH) rechargeable

OK:
Lithium Ion rechargeable
Alkaline rechargeable (Rayovac/RAM)

Best:
No battery at all (e.g. mains or muscle-powered)

10/11. Welsh Slate
Welsh Slate is a very good example of a durable material.

Colours

Colours are produced by pigments, which get onto the material either by a water solution or a solvent (VOC) solution. Obviously, water-based dyes and paints are preferable.

Colour is ubiquitous; you should think about which dyes, inks and paints are being used on everything from fabrics and plastics to glass, paper and metal.

Sadly, it is still easy to find the really nasty metal-oxide pigments like lead and even uranium being used, so check everything you can. Sometimes there is little choice, as in the Titanium or Cobalt oxides used in glass.

There are some acceptable synthetic dyes, but make sure you avoid the hazardous and carcin alkaline and azo-dyes (like benzidine and dianisidine, used in clothing, bedclothes, and leather) and aniline dyes.

In practical terms, the hazard is not to end-users of the product. Hazard arises to workers if they are exposed to solvents or toxic dyes, and to the environment if, for example, water with waste dye is piped out into a river. Generally, the environmental impact of colouring is going to be a very small part of the overall lifecycle impact. However, we should encourage and favour undyed, naturally coloured (e.g. Foxfibre) and vegetable inks/dyes.

The wings of the Morpho butterfly are brightly coloured yet contain no pigment. Work is being carried out to etch similar patterns into materials to give them colour without the contamination of dyes.

Printing

There are several approaches to reduce the impact of printing:
• vegetable-based (soy and linseed) inks that replace petroleum oil with vegetable oil;
• water-based inks that substitute water for solvent;
• waterless inks that eliminate the need for alcohol-containing fountain solution;

12/13. Auro paints
Auro paints have managed to eliminate many of the harmful by-products of paint manufacture.

- energy curable inks and coatings that solidify rather than dry to eliminate the release of Volatile Organic Compounds (VOCs) into the atmosphere.

Paint

There are an increasing number of paint manufacturers making paint which is water soluble, solvent free, petrochemical free, and that use non-azo and non-heavy metal pigments. These paint ranges use:
- plant oils like linseed oil which is mostly from locally-grown organic sources;
- plant and animal waxes like carnauba wax and beeswax;
- earth pigments like umber, ochre and iron oxides;
- plant colours like madder, indigo and mignonette.

Plastics

The rule of thumb is that with plastics, the simpler the better. The more pigment, plasticisers, fire retardants and other additives that are used, the more unfavourable the environmental performance becomes.

However, physical performance such as flexibility and UV resistance is vital for a product to work and so compromises must be made.

Polyethylene and PET are the most commonly recycled plastics and so are the most recyclable ones to use. For recyclability, a limited number of plastics should be used (ideally just one), and they should not be bonded or glued together in a way that compromises their disassembly for recycling.

Urtekram use a single type of plastic for all parts of their shampoo bottles – the cap, label and bottle, so when the company takes them back, they are very easy to recycle. The plastic is itself made of about 30 per cent recycled material.

Other kinds of recycled plastic include Fortrel Ecospun polyester, a very successful material that can be used as textile fibre and Durat, a surface material made of 50 per cent recycled polyester. Rhovyl makes a textile fibre from recycled bottles.

14/15. Recycled plastics
Rhovyl is a textile fibre made from recycled plastic bottles.

APPENDICES

Further Learning

It should take you about 20 minutes to skim this book, maybe two hours to read it closely, and perhaps four hours to think about how it applies to your work and generally let it sink in. After some further reading (see below) and a bit of experimentation in improving and assessing products, you will be looking at having spent 30 hours studying. I hope that at that point you will be starting to feel confident that total beauty and designing a sustainable product will be possible for you. You have your foot on the bottom rung of the ladder.

You've also got to think about how to get colleagues and clients in marketing and engineering and R&D and manufacturing up to speed as well.

Just for context, I've spent about 15,000 hours thinking and working on sustainability.

Here are a few approaches to learning that you might consider:

Read and discuss

The cyclic|solar|safe basics can be got across in a text document or by means of exercises or explorations in small groups. Then about 50 product examples can be displayed, quite quickly, with some narration, to give an overview of the breadth of solutions available. After that, groups can be given a couple of products on which to practise analysis, with a view to them developing the skill of assessing products or potential design innovations very quickly.

Product lunch

Sustainable product lunches are learning lunches where a team of people get together every week to discuss a product. One member of the team selects a product and prepares in advance by getting hold of a sample or a photo and some data, and they run the session. The group analyse the product by following the cyclic|solar|safe|efficient framework, with perhaps a few other criteria thrown in, like 'effectiveness', 'value for money', 'likely success in the marketplace', 'aesthetics', and so on.

The following week another member of the team will present and lead the discussion. Rather than trying to give an absolute score, it is often easier to choose a baseline product to compare a new product with. The market leader is usually a good choice. The human brain is very good at spotting differences, so it is much quicker and easier to say a product is 'more cyclic' or 'less safe' than another, as opposed to giving an absolute score of '100% cyclic', which would require more research.

Product storytelling

I have been involved in the development of the 'Imaginaction' technique (www.imaginaction.org.uk) which uses storytelling to create a vision of the future and then makes a plan to turn that vision into reality.

The technique is ideal for sustainable product design. A product team build a story of the product's entire life history, from raw materials extraction through to end-of-life and beyond. The idea is to look at the human and natural environment perspective, finding out the stories of individual people working in the production chain.

The story can be very terse or flowing and emotive. Usually the more emotive the better, without getting into hyperbole. Detail is important. The goal is to open everyone's eyes to exactly what goes where, what emissions and effluents there are, how the product is really used by the consumer, and so on.

Once this picture is developed, the team has the proper context to start dreaming about an ideal future for the product. Ideas from individuals can be built up into a group story about the ideal product, probably with several options.

Then comes the key part – turning that vision into reality. Fix a date in the future and involve operations and finance staff as necessary to build a plan for what has to happen to get there.

The resulting design directions can then be worked on in the usual way. There will be short- and long-term design goals and briefs. The broader strategic implications can be presented to senior management.

Further reading

If you only want to read three other books, then please read these:

The Green Imperative: Natural Design for the Real World by Victor Papanek, Thames & Hudson; ISBN: 0-500-27846-6
Natural Capitalism: Creating the Next Industrial Revolution by Amory Lovins, Hunter Lovins and Paul Hawken, Little & Brown, 1999, ISBN: 0-316-35316-7
The Timeless Energy of the Sun by Madanjeet Singh, Thames & Hudson, ISBN: 0-500-01851-0

These others are also great:

Industrial Ecology and Global Change by R. Socolow (Ed.) Cambridge University Press, ISBN: 0-521-57783-7

Charging Ahead: The Business of Renewable Energy and What it Means for America by John J Berger, California University Press
ISBN: 0-520-21614-8
Upsizing by Gunter Pauli, GreenLeaf Publishing, ISBN: 1-900-82000-5
Green Design: Design for the Environment by Dorothy Mackenzie, Laurence King Publishers. ISBN: 1-85669-096-2

Web links
Web pages worth a visit are:

The beautifully-designed site for o2, the original network of green designers, is at www.o2.org

The Silicon Valley Toxics Coalition at www.svtc.org is an excellent source of information on the dark side of computers and microchips.

The Institute for Local Self-Reliance, www.ilsr.org has some on-the-button ideas about growing replacements for petroleum products such as fuels and plastics.

The Centre for Alternative Technology at www.cat.org.uk is based in Wales and has a lovely site packed with factsheets and guidance on setting up small-scale energy and waste systems.

The Zero Emissions Research Institute at www.zeri.org in Geneva has an excellent approach to the design of bio-industrial systems and is well worth a visit. ZERI has set out to prove that zero-waste industrial ecology – the clustering of businesses so that one company's waste becomes another company's input, resulting in 100 per cent capture and re-use of resources – is scientifically and commercially feasible.

The Global Futures Foundation at www.globalff.org runs conferences on Industrial Ecology and has lots of good examples of the current practices of their Future 500 companies, the leaders in the U.S. corporate sustainability stakes.

Check out the latest thoughts of green architect Bill McDonough at www.mbdc.com — his speeches in particular are essential reading.

For the latest in eco- and sustainable design, try the Centre for Sustainable Design at www.cfsd.org.uk. They have a great Journal which is available over the web for a small charge, and run many events, including the annual Towards Sustainable Product Development conference.

Focusing on products for the developing world, the UNEP Sustainable Product Group at www.unep.frw.uva.nl in Amsterdam has a database of product examples and has built an extensive network of eco-design practitioners throughout the world.

The Fairtrade Foundation at www.fairtrade.org.uk exists to ensure a better deal for marginalised and disadvantaged third-world producers. Also see CEPAA at www.cepaa.org for details of the social accountability standard SA8000.

Jacquelyn Ottman has some terrific articles at her Green Marketing www.GreenMarketing.com site, including 'Out-of-the-box thinking about environmentally preferable products and services', and her famous 'Getting to Zero' process.

For two great sites about sustainable business in general, make sure you visit Burton Hamner's Sustainable Business Webspace at www.mindspring.com/~bhamner, and the late Colin Hutchinson's excellent site at www.applysd.co.uk

For some Bio-inspiration, the full text of Kevin Kelly's book *Out Of Control* can be found at www.well.com/user/kk/OutOfControl

Carnegie Mellon University offer some useful educational materials on Green Design at www.ce.cmu.edu/GreenDesign/education.html

Final note to readers

When you put down this book and go to make your product more sustainable, you will immediately find people who will tell you why it can't be done.

This is natural. The product didn't become successful by having people mess around with it for no reason. A successful formula should be protected and nurtured. But it shouldn't ossify. To succeed in the 21st century, your product has to be a stunning environmental performer, and your job is to wake it up and knock it into shape.

It also seems likely that environmental sensibilities will become incorporated into culture. Products have already evolved in terms of safety; then came quality, and then design and aesthetics. Environment will be next – products that do not just look nice, but which are nice underneath and in the way that they were made.

People are aware of manufacturing and the environmental and social costs it can have. People are starting to become aware of depth, and are finding that pure façade and surface beauty is not enough. Design students have always been taught Form and Function, but will be taught more about the impacts of Fabrication, so they can understand the provenance of products and the full implications of their design choices.

Finally, the new sustainable products must be new variants on existing mainstream products. Sustainability is not a niche phenomenon. Total beauty is for everyone.

What seems radical today, will be mainstream tomorrow.

All the products pictured in the book show that environmental performance and aesthetics can go hand in hand. But there are some products that are beautiful underneath because they have excellent environmental and social performance, but are frankly not that attractive. You can apply your design skills to turn these ugly ducklings into beautiful swans.

cyclic|solar|safe is the best tool for understanding products and how they can become more environmentally sustainable. It is fast and easy to use, whether you are designing a product or considering buying it.

Becoming 100 per cent sustainable is not only possible, it can be achieved by the year 2100. By moving away from the "how can we be less bad?" mentality to the "how can we be 100 per cent good?" mindset, we give ourselves the capability of redesigning every product to be 100 per cent cyclic, solar and safe.

One day, all products will be like this. **Make today be the first step towards that day.**

Picture Credits:

p2 BRE Environmental Building at Garston, with thanks and acknowledgement to BRE Ltd.; pp6–7 Cracked dry earth, Sussusvlei, Namib desert, Namibia, © Environmental Images, photography by Amanda Gazidis; p10 Emeco Hudson chair by Philippe Starck, with thanks and acknowledgement to Emeco; p10 C3 stacking chair by Trannon, with thanks and acknowledgement to Trannon Furniture Ltd.; p10 SoftAir inflatable chair, with thanks and acknowledgement to News Design DFE AB; p11 Louis 20 chair by Philippe Starck, with thanks and acknowledgement to Vitra, photography by Miro Zagnoli; p11 Picto chair, with thanks and acknowledgement to Wilkhahn; p24 No-Shank finger toothbrush, with thanks and acknowledgement to Securitas, Inc., photography by Xavier Young; p33 Lightning image, © Digital Vision; p34 Duracell 'blister-free' blister pack for AA batteries, with thanks and acknowledgement to MDPR; p34 Dahle recycled scissors, with thanks and acknowledgement to Dahle (UK) Ltd.; p35 Preserve recycled toothbrush, with thanks and acknowledgement to Recycline; p35 Tear-strip envelope, with thanks and acknowledgement to Dual Envelope & Co., photography by Xavier Young; pp36–37 Wooden cutlery, with thanks and acknowledgement to HOLZSPECHT Holzbestecke GmbH; p37 Dragon bicycle, with thanks and acknowledgement to Candytape Ltd.; pp38–39 Sunset image, © Digital Vision; p41 Sunset image, © Digital Vision; p42 Citizen Promaster tough solar watch, with thanks and acknowledgement to Citizen Watch (UK) Ltd.; p42 Pathfinder-Plus solar-powered aircraft, with thanks and acknowledgement to NASA Dryden Flight Research Center Photo Collection, photography by Nick Galante; p43 CookSack portable solar oven, with thanks and acknowledgement to Jonathan Stoumen Architects; p44 Taxi bike, with thanks and acknowledgement to Advanced Vehicle Design; p44 Patagonia fleece, with thanks and acknowledgement to Patagonia; p45 Brompton folding bicycle, with thanks and acknowledgement to Brompton Bicycle Ltd.; p45 Seiko thermic watch, with thanks and acknowledgement to Seiko Corporation; p49 Rippling water image, © Digital Vision; p50 Design Tex upholstery fabric, with thanks and acknowledgement to Rohner Textil AG, photography by Xavier Young; p51 Nike shoe, with thanks and acknowledgement to Nike; p51 Nike shoe box, with thanks and acknowledgement to Nike; pp52–53 Powabyke electric bicycle, with thanks and acknowledgement to Powabyke; p53 FSC-certified copier paper, with thanks and acknowledgement to Dudley Stationery Ltd.; p53 Prius Hybrid electric car, with thanks and acknowledgement to Toyota (GB) PLC; pp54–55 The edge of the Nordic ice shelf is collapsing into the sea, Antarctica, © Environmental Images, photography by Steve Morgan; p57 Close-up leaf image, © Digital Vision; p58 No-Shank finger toothbrush, with thanks and acknowledgement to Securitas, Inc., photography by Xavier Young; p58 Quattro multifunctional power tool, with thanks and acknowledgement to Bergmans PR Consultants/Black & Decker; p59 Cham interchangeable heel shoes, with thanks and acknowledgement to Trippen; p59 Tripp Trapp growing chair, with thanks and acknowledgement to PJP Partnership; p60 Digicam 400 SolarCam, with thanks and acknowledgement to Sanyo; p60 Bag for Life, with thanks and acknowledgement to J. Sainsbury's Supermarket Ltd.; p60 Ecosys long-life printer, with thanks and acknowledgement to Kyocera Electronics UK Ltd.; p61 Millennium II Spacepen, with thanks and acknowledgement to Fisher Spacepen Co./GBA Pen Company Ltd., photography by Xavier Young; p61 Sri Swaminaryan Hindu Temple in Neasden, London, with thanks and acknowledgement Brent Council; p63 Pollution victim – dying tree near Port Talbot, South Wales, © Environmental Images, photography by Martin Bond; p65 Leaf-cutting ants, © Digital Vision; pp66–67 Auro paints, with thanks and acknowledgement to AURO Organic Paints AG; p67 Picto chairs, with thanks and acknowledgement to Wilkhahn; pp68–69 Large tornado (F3) near Elba, Colorado, USA, © Environmental Images; p72 Flower image, © Digital Vision; p74–75 Ecological house, with thanks and acknowledgement to Nick White, Hockerton Housing Project; p76 REN Seaweed and Sage Body Wash, with thanks and acknowledgement to REN, photography by Xavier Young; pp78–79 Ridgeways Tea, with thanks and acknowledgement to Ridgways, photography by Xavier Young; p80 Sony ICF-B200 wind-up radio, with thanks and acknowledgement to Sony International, photography by Xavier Young; p82 OAO organic muesli by Philippe Starck, with thanks and acknowledgement to OAO, photography by Xavier Young; p83 Organic soy milk, with thanks and acknowledgement to Provamel, photography by Xavier Young; p84 Can-O-Worms organic waste processor, with thanks and acknowledgement to Wiggly Wigglers Ltd.; p85 Ecobin, with thanks and acknowledgement to Special EFX Ltd.; p86 Foxfibre organic cotton socks, with thanks and acknowledgement to Natural Cotton Colours, Inc., photography by Xavier Young; p87 Haferl shoes, with thanks and acknowledgement to Trippen; p88 Mondaine Ecomatic watch, with thanks and acknowledgement to Mondaine Watch Ltd.; p90 Patagonia fleece, with thanks and acknowledgement to Patagonia; p91 Artisan hemp briefcase, with thanks and acknowledgement to Artisan Gear, photography by Xavier Young; pp92–93 TH!NK electric car, with thanks and acknowledgement to TH!NK Nordic AS; p94 BRE Environmental Building at Garston, with thanks and acknowledgement to BRE Ltd.; p96 Aeron chair, with thanks and acknowledgement to Herman Miller; p99 Phenix Biocomposite desk, with thanks and acknowledgement to Horst, Inc.; pp100–101 Cornstarch pen, with thanks and acknowledgement to the Centre for Alternative Technology, photography by Xavier Young; p103 Furnature chair, with thanks and acknowledgement to Furnature; p104 solar-dried coffee, photography by Xavier Young; p105 Solait milk frother, with thanks and acknowledgement to Dalia Cutlery; p107 Remarkable pencils, with thanks and acknowledgement to Remarkable Pencils Ltd., photography by Xavier Young; p108 Evolve paper, with thanks and acknowledgement to UK Paper, photography by John Suett; p109 Xerox DC265, with thanks and acknowledgement to Xerox Corporation; p110 Rental DVD, photography by Xavier Young; p113 Waterless urinal, with thanks and acknowledgement to Armitage Shanks; Prang soybean crayons, with thanks and acknowledgement to Dixon Ticonderoga Co.; pp116–117 Emeco Hudson chair by Philippe Starck, with thanks and acknowledgement to Emeco; pp118–119 ES-X2 Electric Scooter, with thanks and acknowledgement to PUES Corporation; p120 e.light, with thanks and acknowledgement to Artemide; p124 VW Lupo 3L, with thanks and acknowledgement to Volkswagen AG; p125 VW Lupo 3L, with thanks and acknowledgement to Volkswagen AG; p126 Organic beer, photography by Xavier Young; p127 Vestfrost fridge, with thanks and acknowledgement to A/S Vestfrost; p128 Zanussi IZ washing machine, with thanks and acknowledgement to GCI Jane Howard/Zanussi; p131 Windmill image, with thanks and acknowledgement to NEG Micon A/S; p133 Dunlop recycled boots, with thanks and acknowledgement to DUNLOP Hevea; pp134–135 Nightstar torch, with thanks and acknowledgement to Applied Innovative Technologies, Inc., photography by Xavier Young; p136 Potatoes, photography by Xavier Young; p137 Carrots, photography by Xavier Young; p138 Martin SWD wood guitar, with thanks and acknowledgement to The Martin Guitar Company; p139 Guitar strings, with thanks and acknowledgement to J. D'Addario & Company, Inc., photography by Xavier Young; p140 OR'ION salt lamps, with thanks and acknowledgement to Ion Design Ltd.; p142 SS-BG30 Tectan loudspeakers, with thanks and acknowledgement to Sony International Europe GmbH; p145 SoftAir inflatable sofa, with thanks and acknowledgement to News Design DFE AB; p146 Radius original toothbrush, with thanks and acknowledgement to RADIUS Toothbrush; p147 Urtekram toothpaste, with thanks and acknowledgement to Urtekram A/S, photography by Xavier Young; p149 Natura bed, with thanks and acknowledgement to Natura World Inc.; p160 Hess Natur briefcase, with thanks and acknowledgement to Mohndruck GmbH; p160 Clima wool, with thanks and acknowledgement to Klober Limited, photography by Xavier Young; p161 Foxfibre cotton, with thanks and acknowledgement to Natural Cotton Colours, Inc.; p161 Jeans pencil, with thanks and acknowledgement to Sanford Corporation/Berol Corporation, photography by Xavier Young; p162 Ecover plastic bag, with thanks and acknowledgement to Ecover, photography by Xavier Young; p163 Hooke park, with thanks and acknowledgement to The Parnham Trust at Hooke Park, Dorset; p163 Plyboo flooring, with thanks and acknowledgement to Smith & Fong Company; p163 Highlighter pencil, with thanks and acknowledgement to Paperback, photography by Xavier Young; p164 Kyocera knife, with thanks and acknowledgement to Kyocera Fineceramics GmbH; p165 Welsh Slate, with thanks and acknowledgement to Welsh Slate, photography by Xavier Young; p165 Welsh Slate cladding, with thanks and acknowledgement to Welsh Slate; p166–167 Auro paints, with thanks and acknowledgement to AURO Organic Paints AG; p167 Recyclable plastics, with thanks and acknowledgement to Rhovyl, photography by Xavier Young; p167 Recyclable plastics, with thanks and acknowledgement to Rhovyl, photography by Xavier Young.

Acknowledgements:

Many thanks to:

Gina for the pasta salad;
The book's editor Zara Emerson at RotoVision;
Picture researchers Erica Ffrench, Tina Bell and Nicole Mendelsohn at RotoVision.

Many of the ideas in this book were inspired by conversations I have had with the following – thanks to you all:

Jo, Julian, Kerry, Bev, Claire and Hannah at www.naturalcollection.com; Martin Wright at Green Futures; Roberto Forcén at cíclico|solar|seguro; Phil Thompson at Electrolux and Whirlpool; Gillian Shaw at Bluefish; Dave Stanley, Martin Diaper and Deb Harrity at the Environment Agency; Andy Wales and Steve Martin at Interface; Caroline Rennie at Tetra Pak; and Professor Mike Ashby and Dr Ulrike Wegst at Cambridge University. And of course, all the BioThinkers!